WHY I MARCH

IMAGES FROM THE WOMEN'S MARCH AROUND THE WORLD

WITH PHOTOGRAPHS BY GETTY IMAGES

ABRAMS IMAGE, NEW YORK

JANUARY

"I stand here today most of all because I am my sister's keeper."

Janet Mock

"...This Women's March represents the promise of feminism as against the pernicious powers of state violence. An inclusive and intersectional feminism that calls upon all of us to join the resistance to racism, to Islamophobia, to anti-Semitism, to misogyny, to capitalist exploitation."
Angela Davis

"We reject the dehumanization of our Muslim mothers and sisters. We demand an end to the systemic murder and incarceration of our black brothers and sisters. We will not give up our right to safe and legal abortions. We will not ask our LGBTQ families to go backwards. We will not go from being a nation of immigrants to a nation of ignorance."
America Ferrera

"Sisters and brothers, fear is a choice. We are the majority. We are the conscience of these United States of America. We are this nation's moral compass."
Linda Sarsour

"When you feel that we are not taking care of one another properly, put your feelings aside, put your pride aside, and stand up for the most marginalized people in this society. Because if you stand for them, you stand for all."
Tamika Mallory

"...Because we are together, each of us individually and collectively will never be the same again. When we elect a possible president we too often go home. We've elected an impossible president. We're never going home. We're staying together."
Gloria Steinem

"Si no nos dejan soñar, no los vamos a dejar dormir. If they don't let us dream, we will not let you sleep."
Carmen Perez

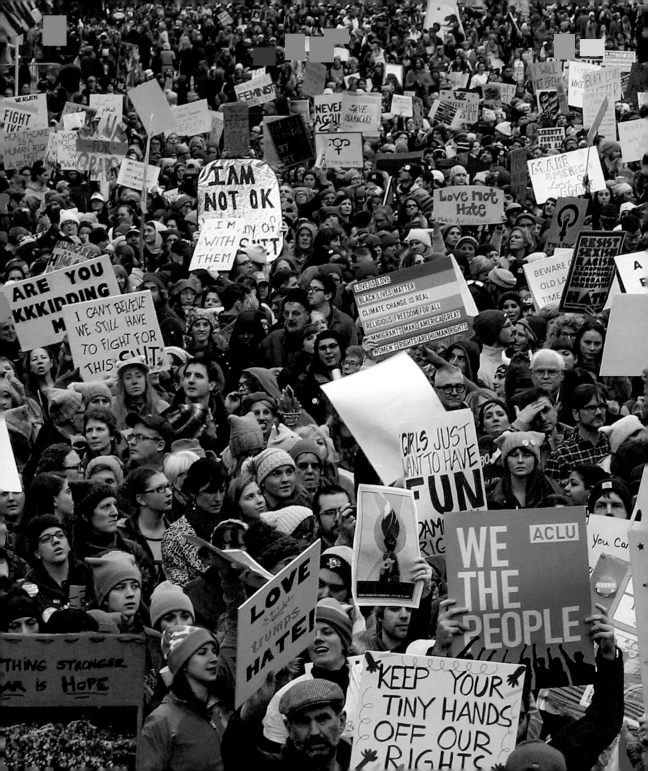

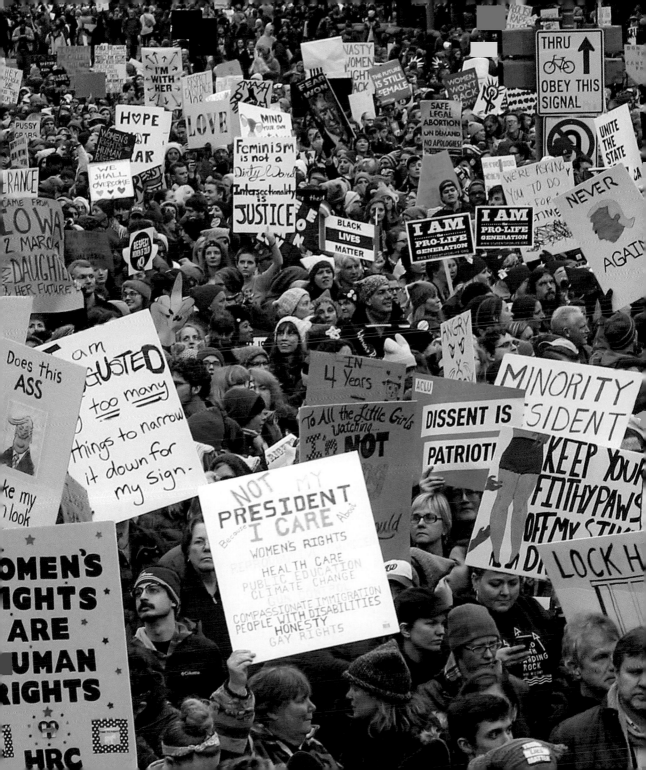

NOF
AME

ALABAMA, ALASKA, ARIZONA, ARKANSAS,
CALIFORNIA, COLORADO, CONNECTICUT,
DELAWARE, FLORIDA, GEORGIA, HAWAII, IDAHO,
ILLINOIS, INDIANA,IOWA, KANSAS, KENTUCKY,
LOUISIANA, MAINE, MARYLAND, MASSACHUSETTS,
MICHIGAN, MINNESOTA, MISSISSIPPI, MISSOURI,
MONTANA, NEBRASKA, NEVADA,
NEW HAMPSHIRE, NEW JERSEY, NEW MEXICO,
NEW YORK, NORTH CAROLINA,

RTH
RICA

NORTH DAKOTA, OHIO, OKLAHOMA, OREGON, PENNSYLVANIA, PUERTO RICO, RHODE ISLAND, SOUTH CAROLINA, SOUTH DAKOTA, TENNESSEE, TEXAS, UTAH, VERMONT, VIRGINIA, WASHINGTON, WASHINGTON, D.C., WEST VIRGINIA, WISCONSIN, WYOMING, THE BAHAMAS, BERMUDA, CANADA, CAYMAN ISLANDS, COSTA RICA, GUAM, MEXICO, SAINT KITTS & NEVIS, U.S. VIRGIN ISLANDS

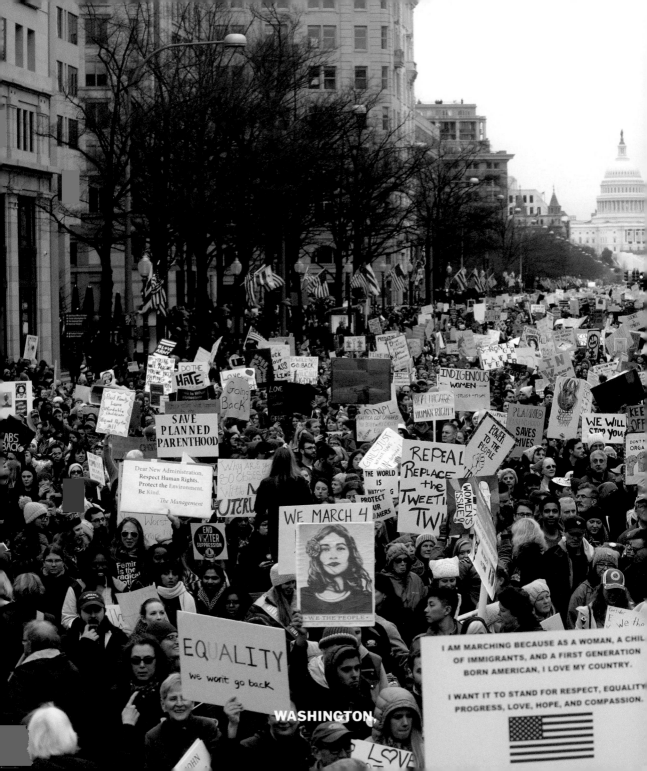

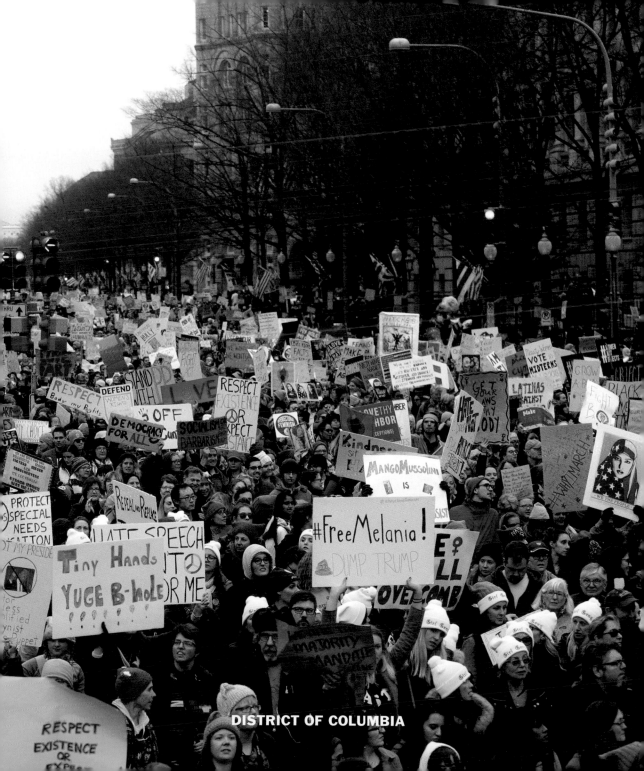

DISTRICT OF COLUMBIA

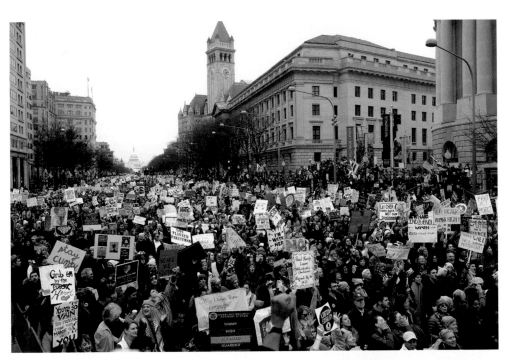
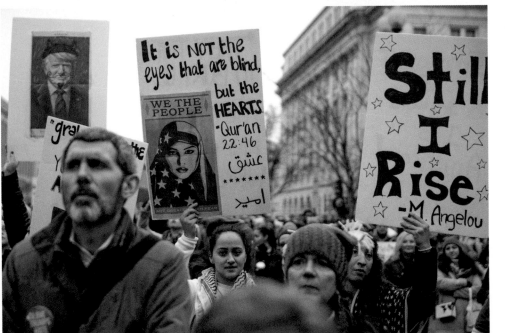

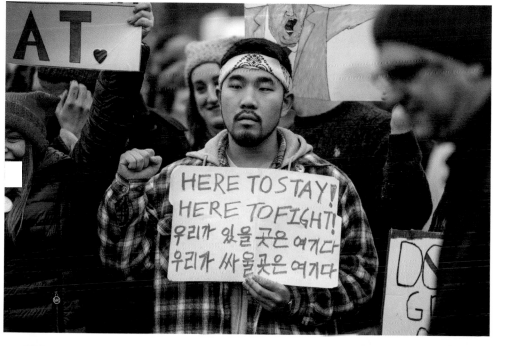

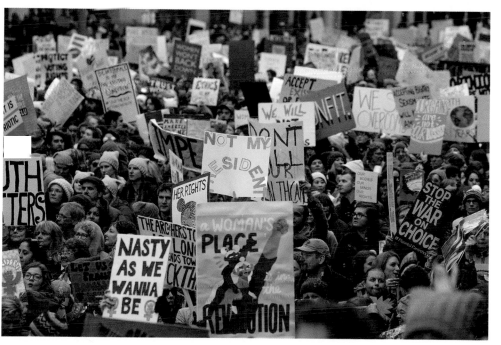

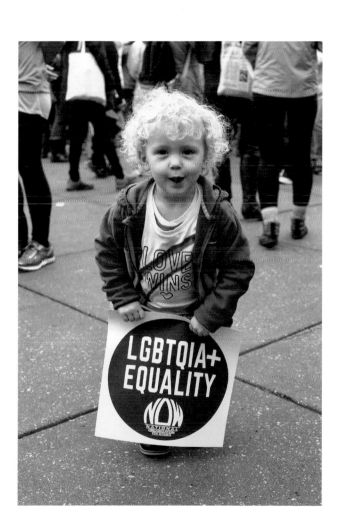

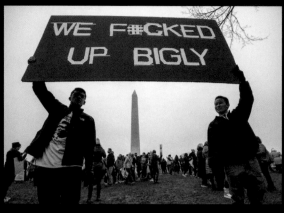

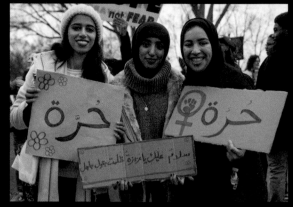

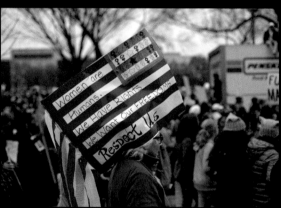

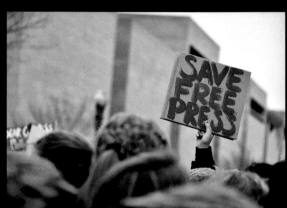

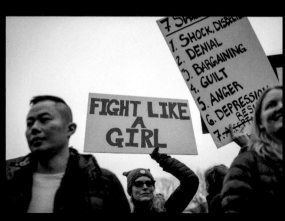

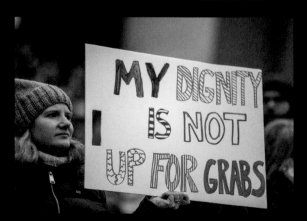

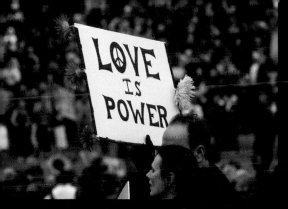

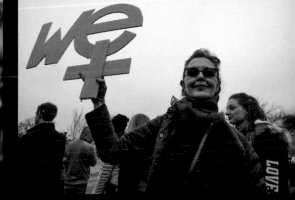

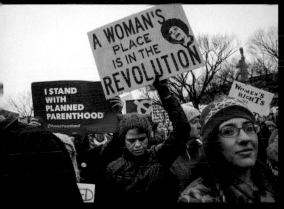

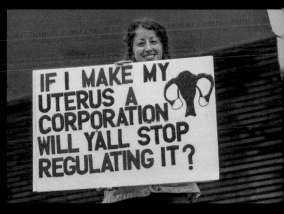

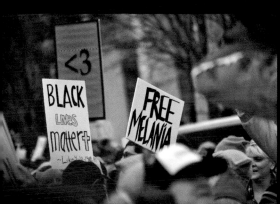

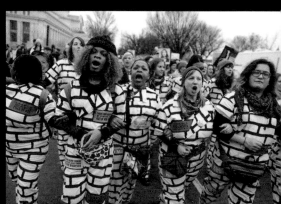

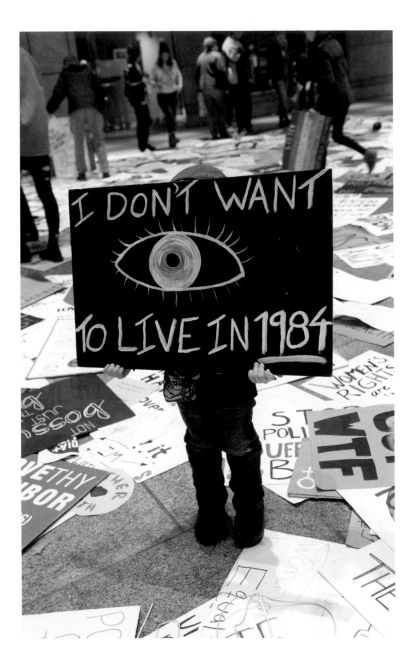

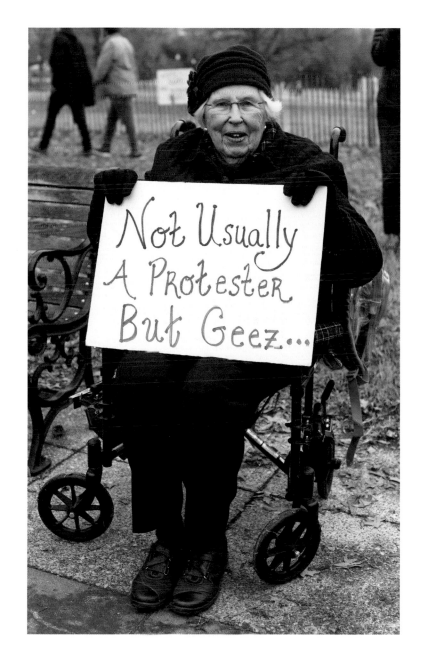

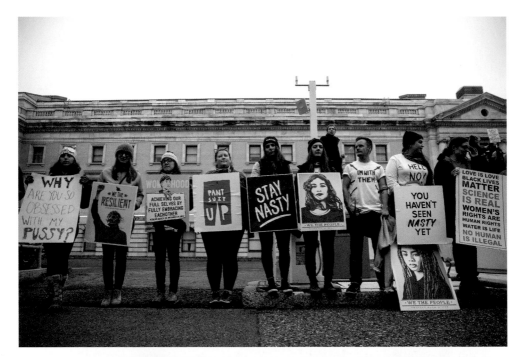

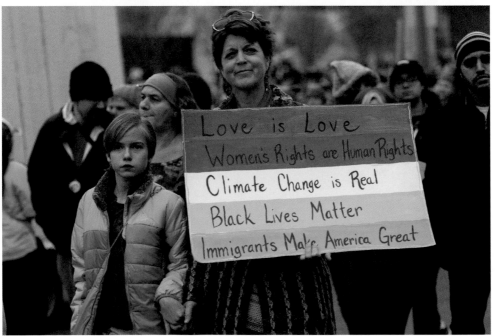

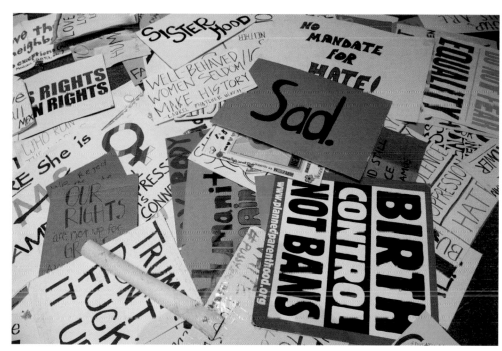

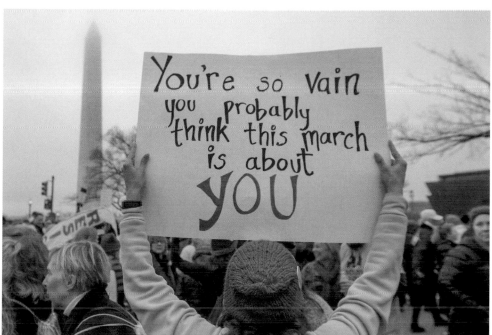

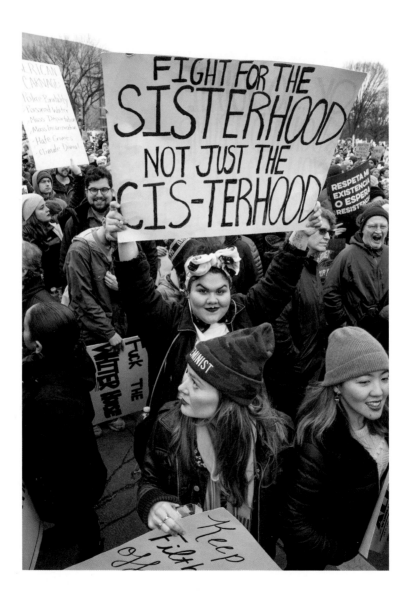

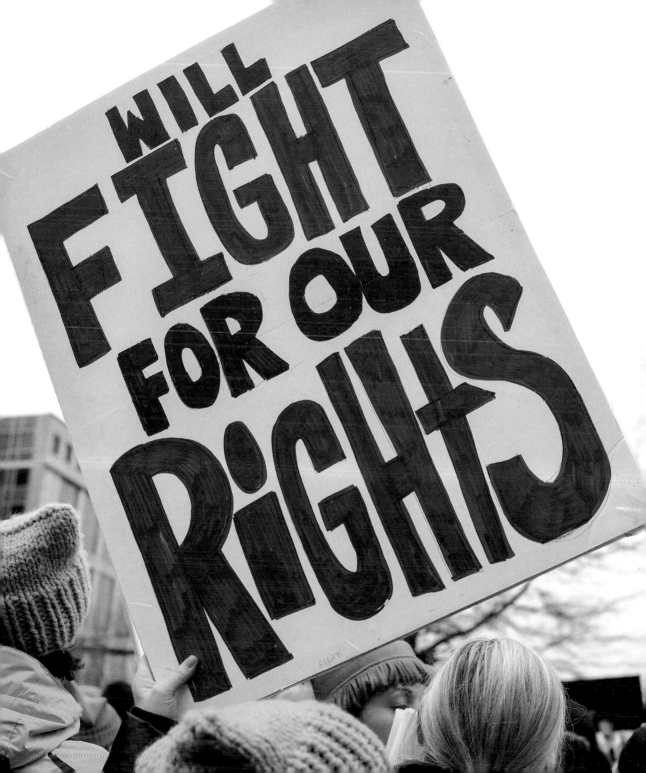

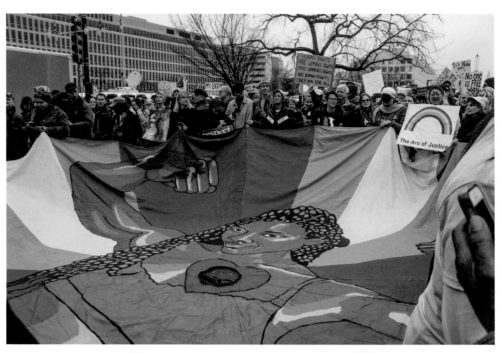

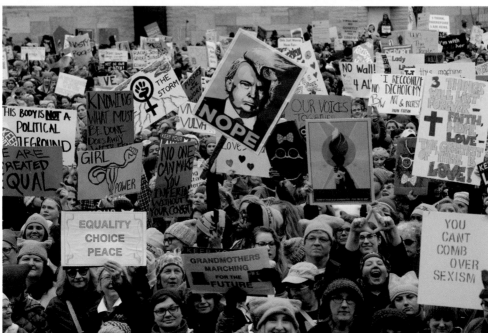

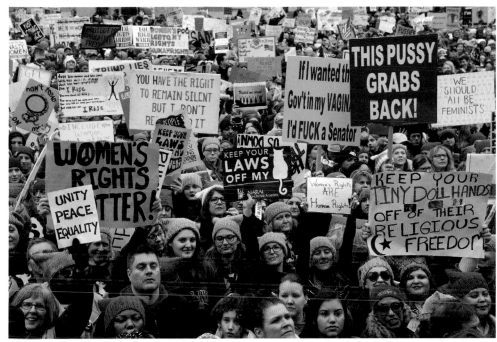
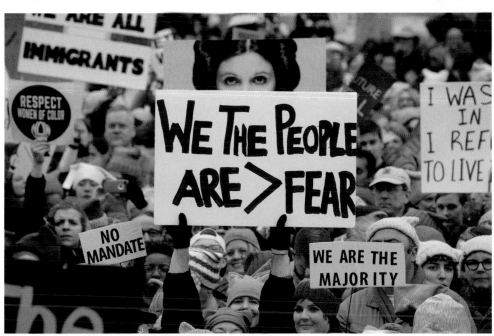

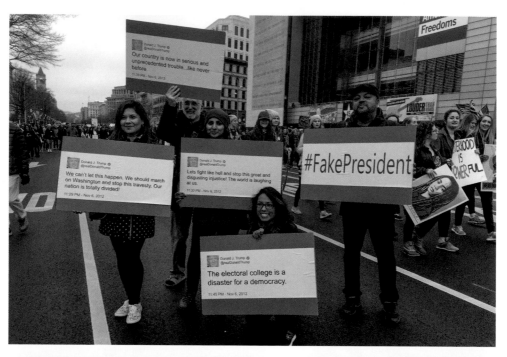

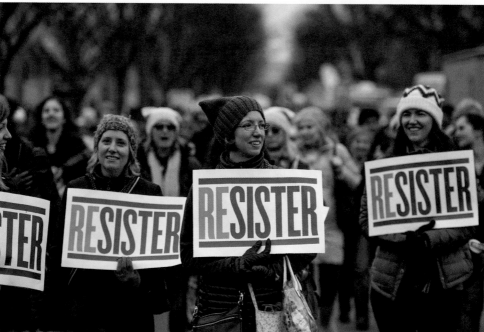

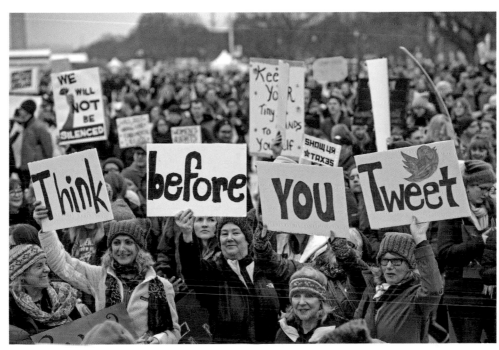

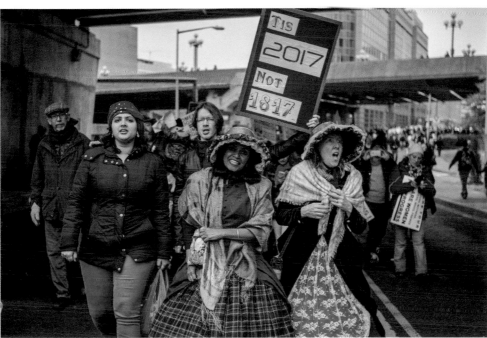

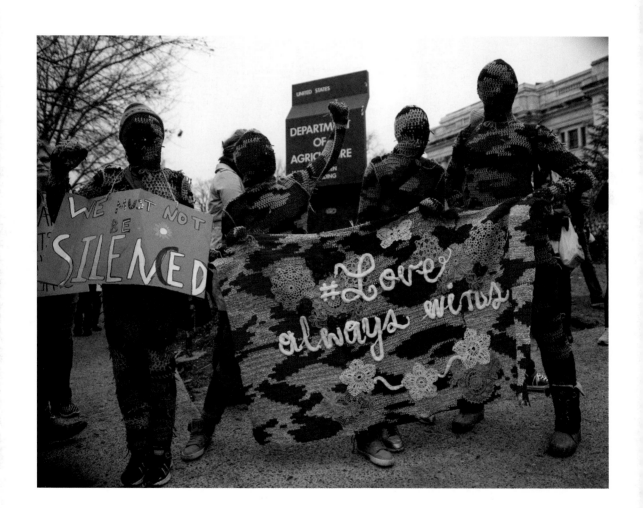

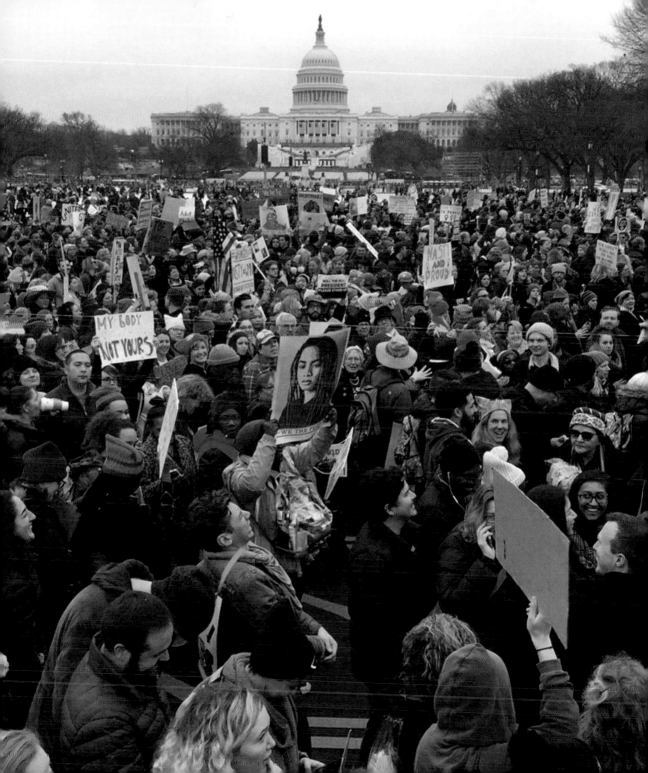

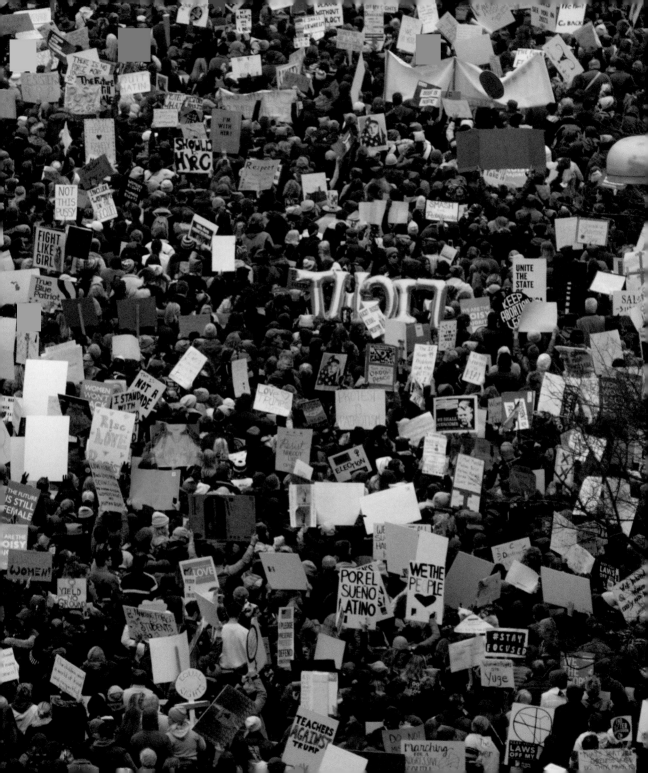

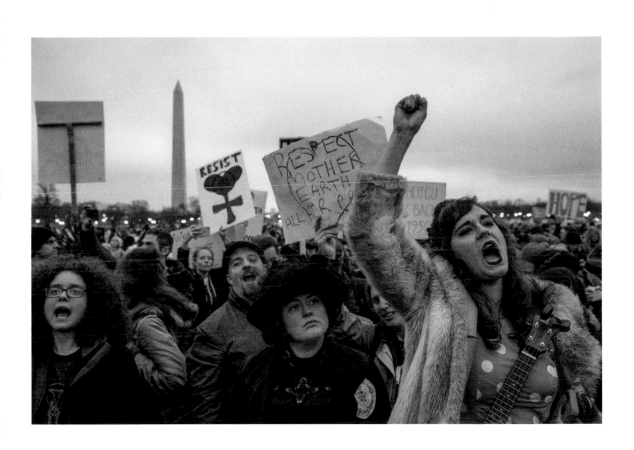

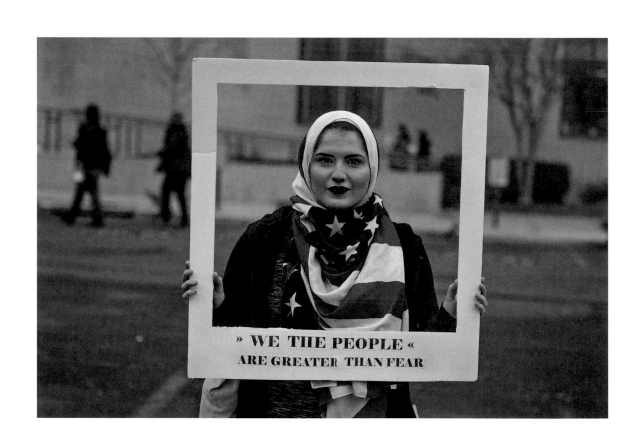

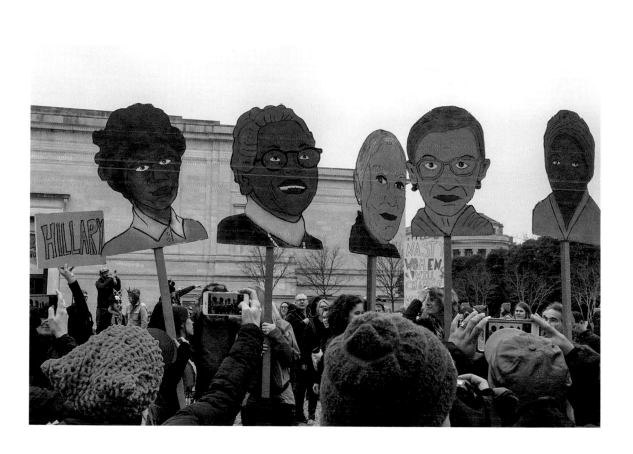

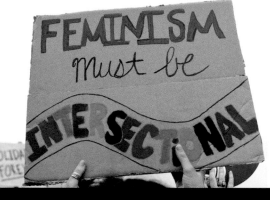

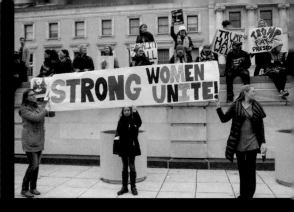

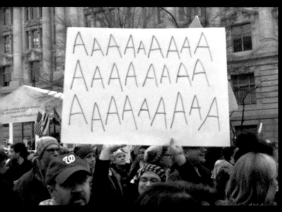

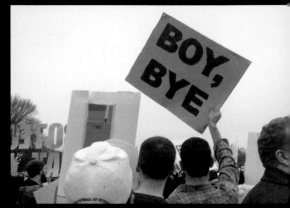

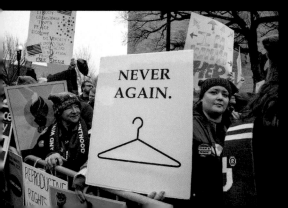

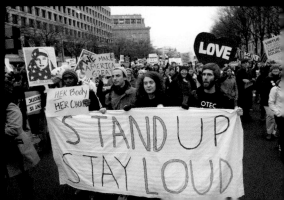

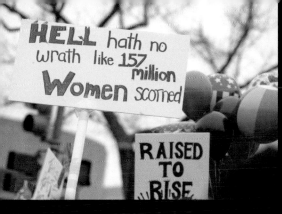

HELL hath no wrath like 157 million Women scorned

RAISED TO RISE

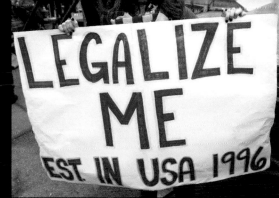

LEGALIZE ME
EST IN USA 1996

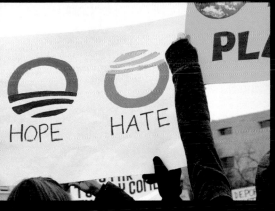

HOPE HATE

PL

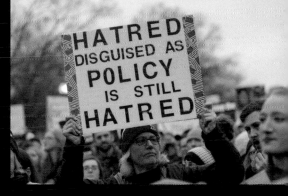

HATRED DISGUISED AS POLICY IS STILL HATRED

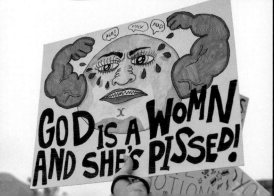

AH! FUCK AUG!

GOD IS A WOMN AND SHE'S PISSED!

HUMAN RIGHTS ARE WOMEN'S RIGHTS

MISOGYNY KILLS

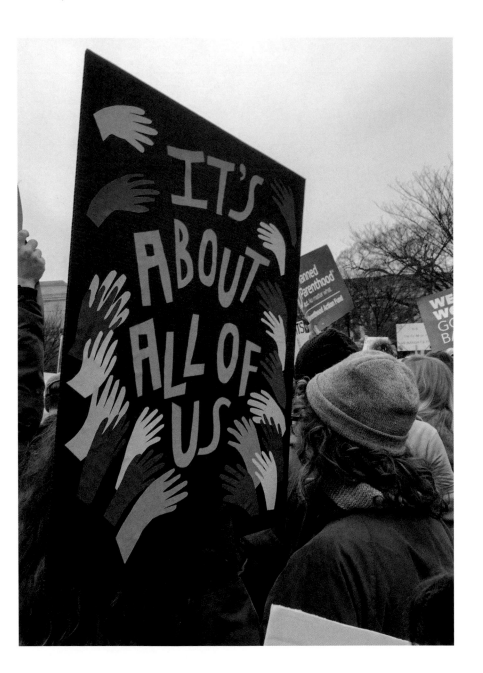

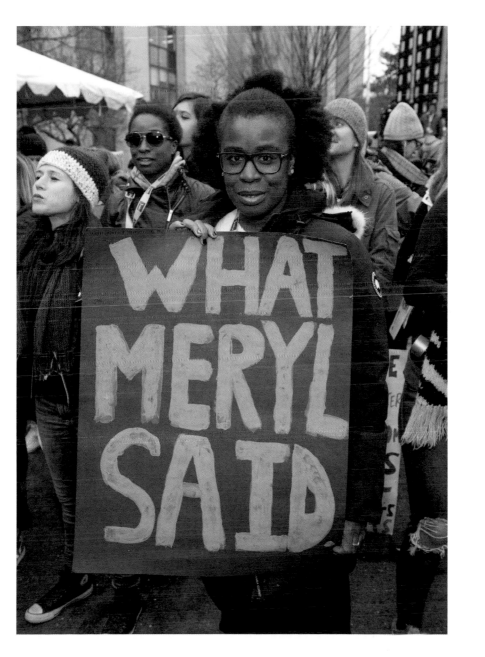

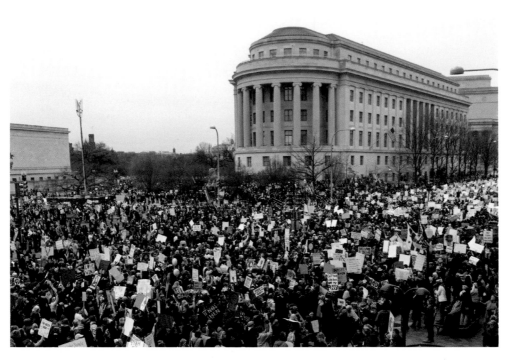

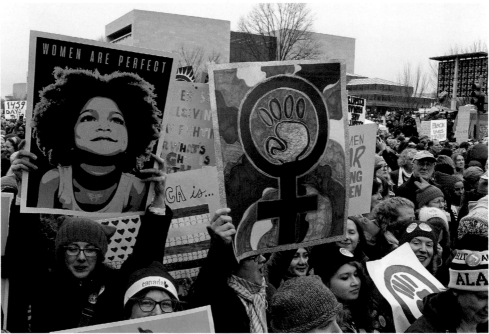

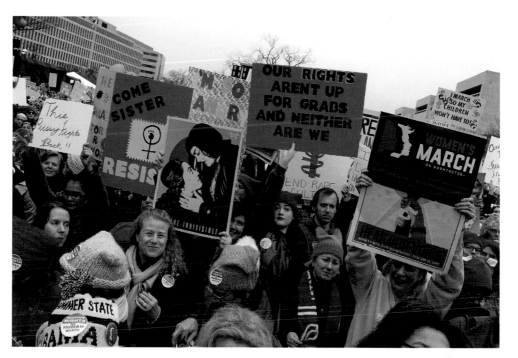

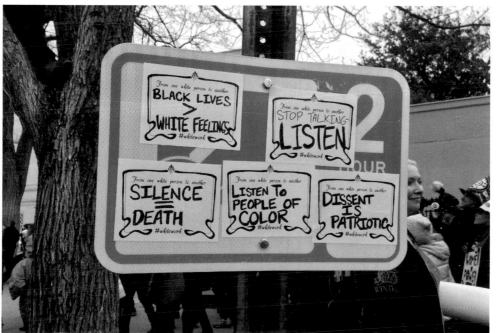

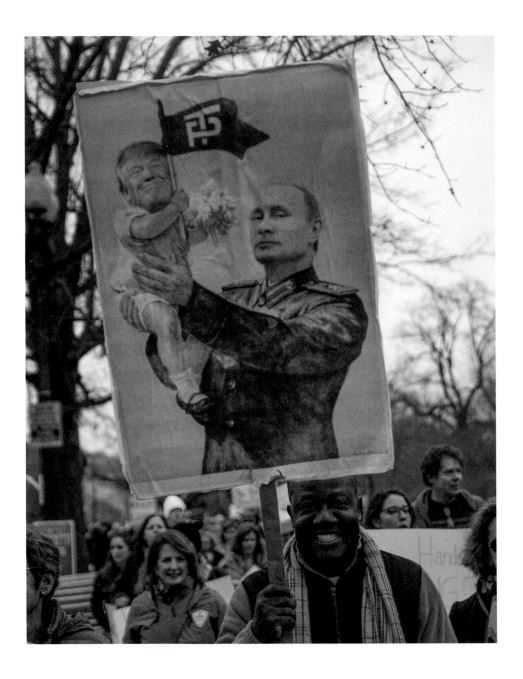

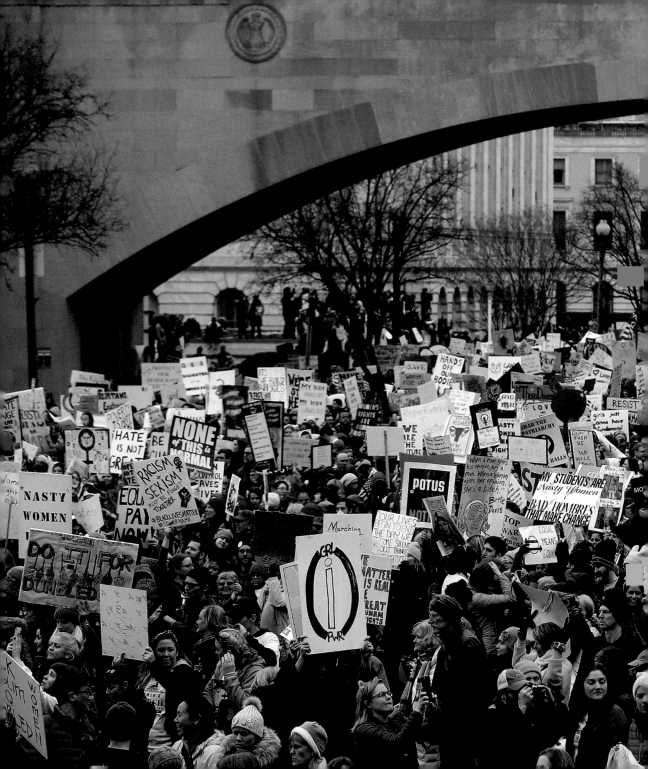

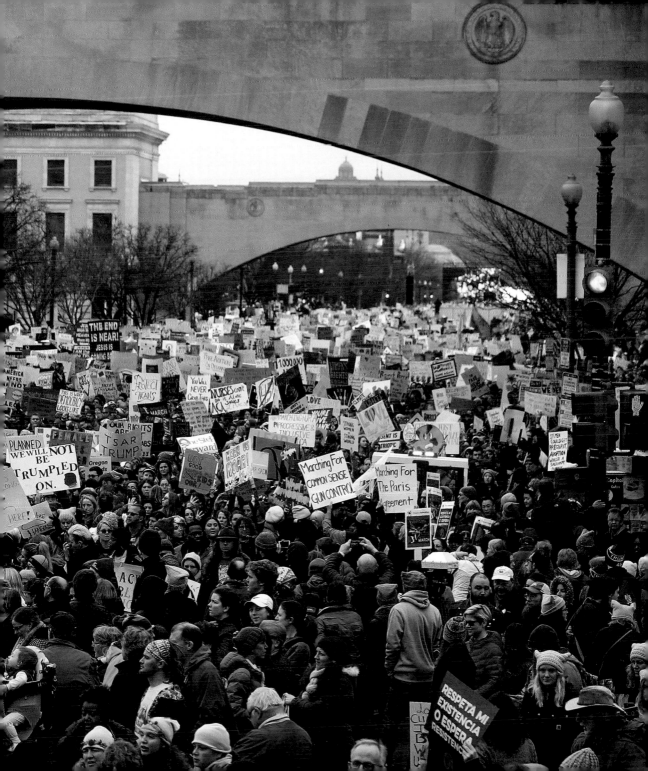

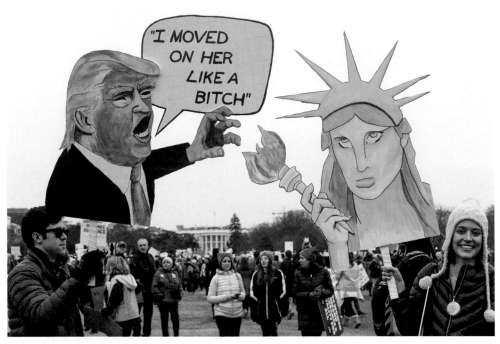

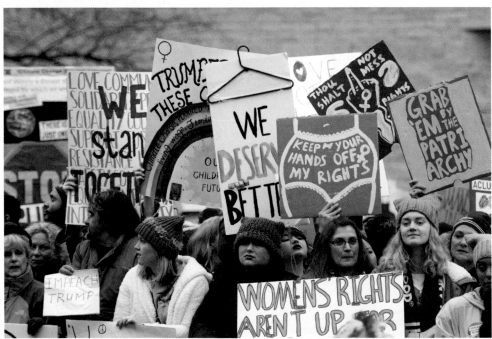

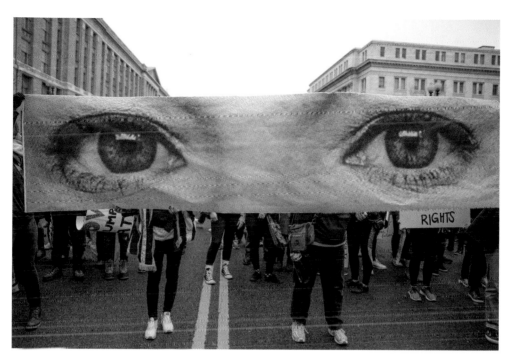

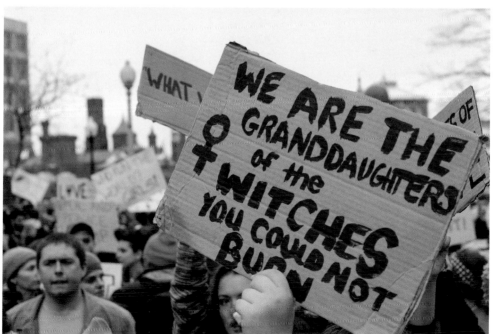

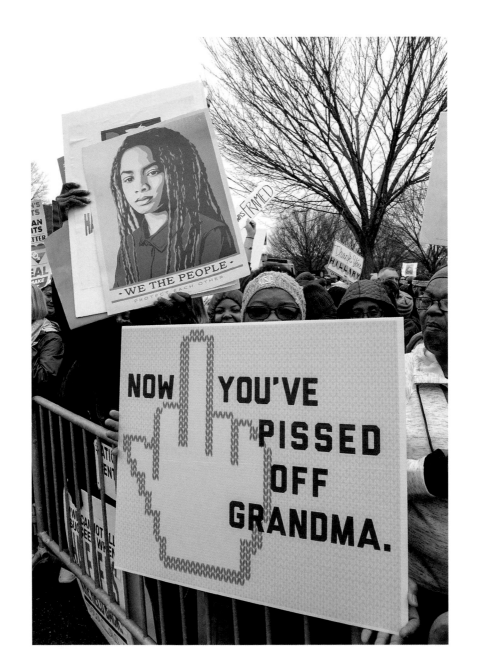

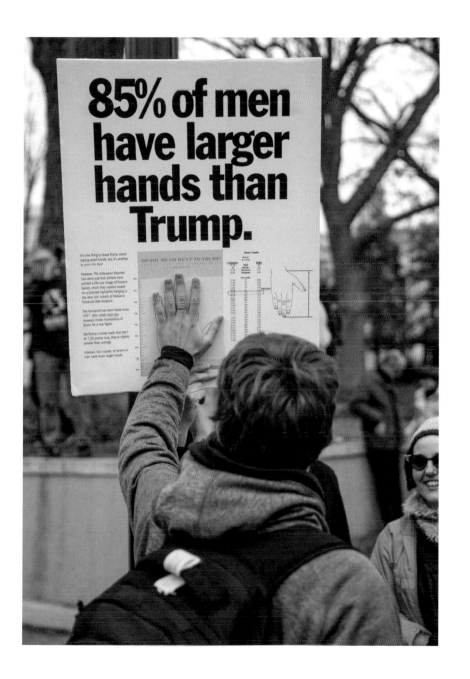

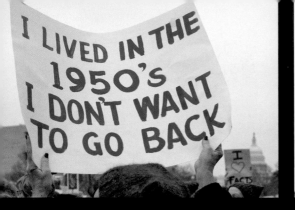

I LIVED IN THE 1950's I DON'T WANT TO GO BACK

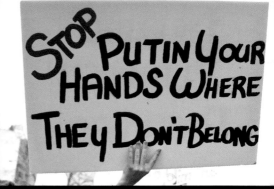

STOP PUTIN YOUR HANDS WHERE THEY DON'T BELONG

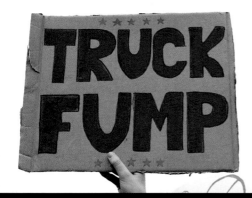

TRUCK FUMP

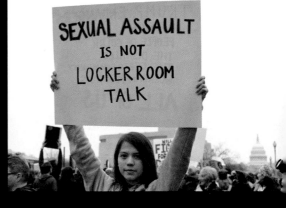

SEXUAL ASSAULT IS NOT LOCKER ROOM TALK

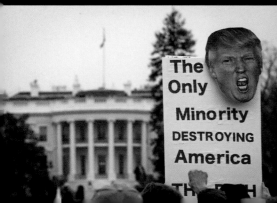

The Only Minority DESTROYING America

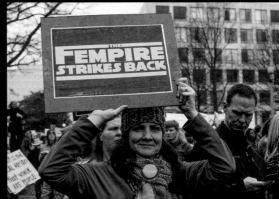

THE FEMPIRE STRIKES BACK

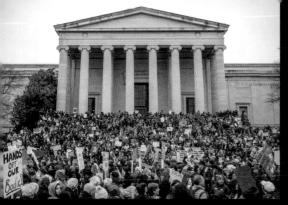

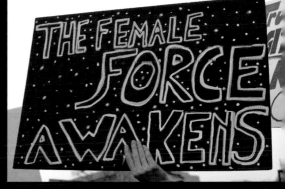

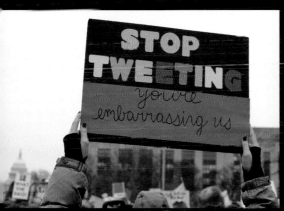

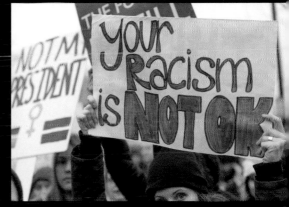

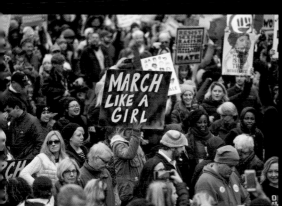

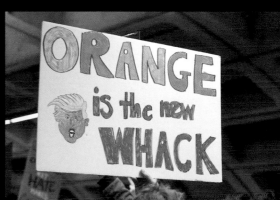

Gracias

SCAM

#NotMyPresident

TIDE

CAUSED BY CLIMATE CHANGE

PUSSY GRABS BACK.

DISSENT IS PATRIOTIC

HAND TOO SMALL CAN'T BUILD A WALL!

GOVERNMENT IS NOT THE ENEMY

Feminism IS NOT TO MAKE MEN WEAKER — IT IS TO MAKE Society

Divided NOT

PEOPLE AND PLANET NOT PIPELINE AND PRO

MARCHING FOR EVERYONE'S FUTURE

Everything we see in the world is the creative work of women. A

WOMEN'S MARCH ON WASHINGTON

TS ARE HUMAN RIGHTS

TRUMP. "SAD!"

IT I'M IT'S MAR

abortion rights

TRUMP: "GUILTY AS HELL"

#1 MOTHER EARTH

S A FOSSIL Fool WER RULES

TER OR SNOCLOTHS HE'S A ZERO'D

We're Here & We're Queer

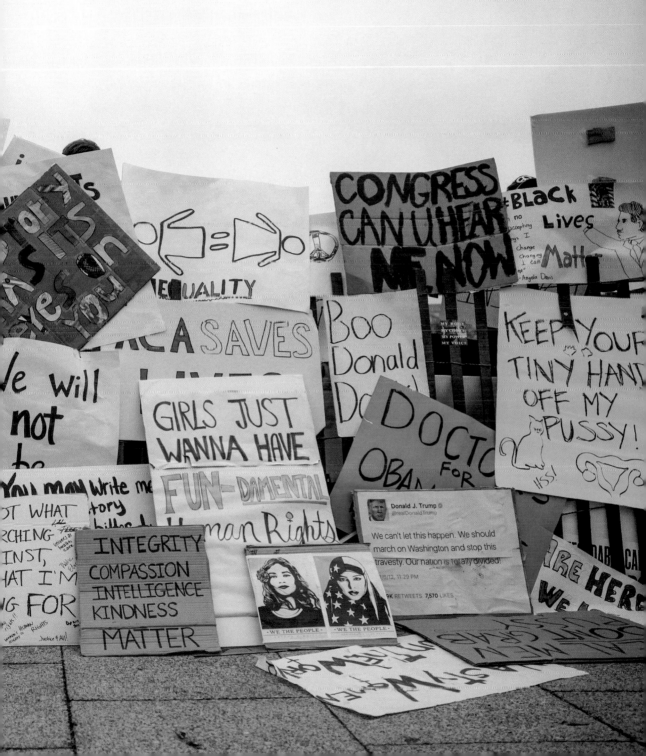

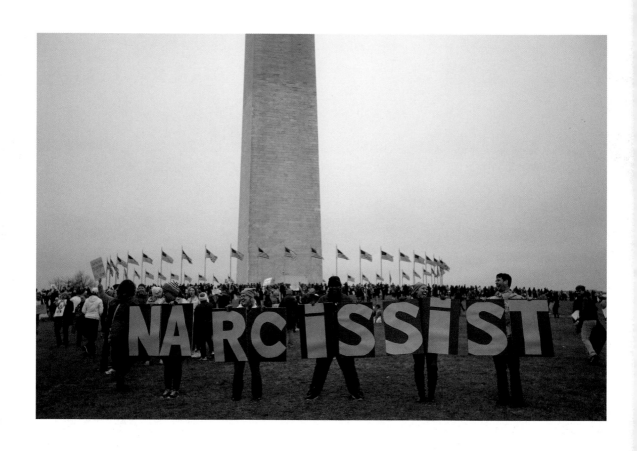

WASHINGTON, D.C.

SISTER
MARCHES

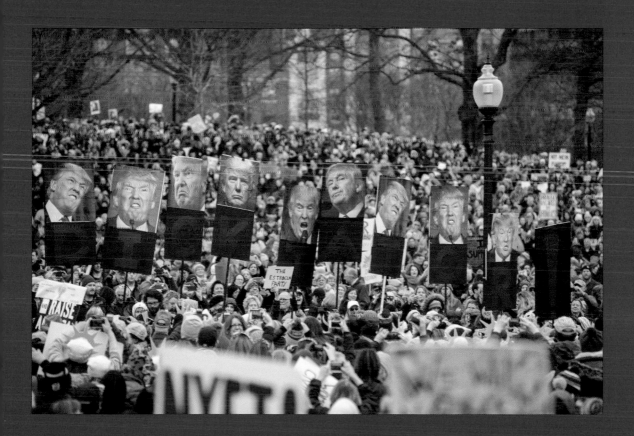

BOSTON, MA

SEATTLE, WA

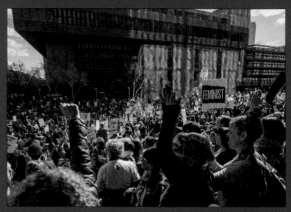

LOS ANGELES, CA

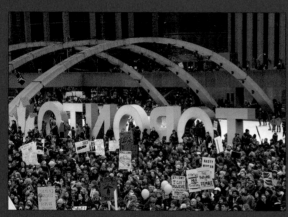

TORONTO, CANADA

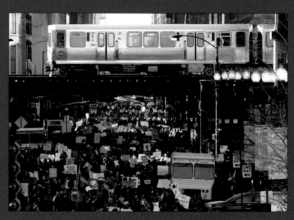

CHICAGO, IL

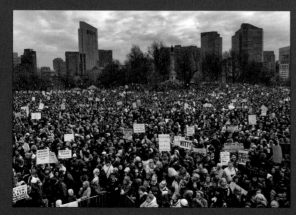

BOSTON, MA

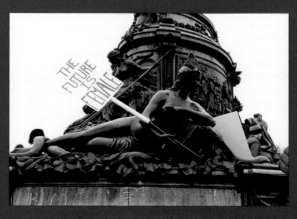

PHILADELPHIA, PA

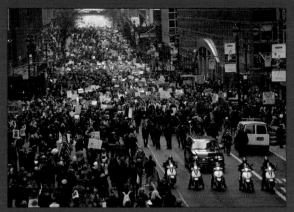

NEW YORK, NY

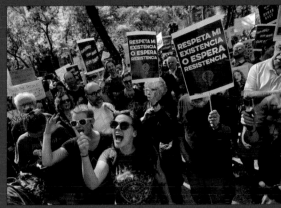

MEXICO CITY, MEXICO

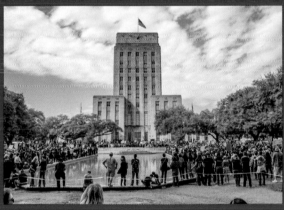

HOUSTON, TX

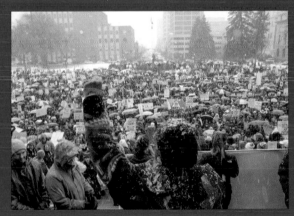

BOISE, ID

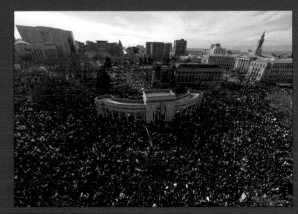

DENVER, CO

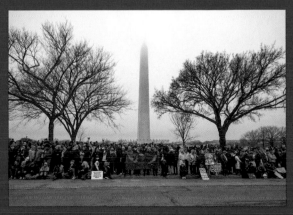

WASHINGTON, D.C.

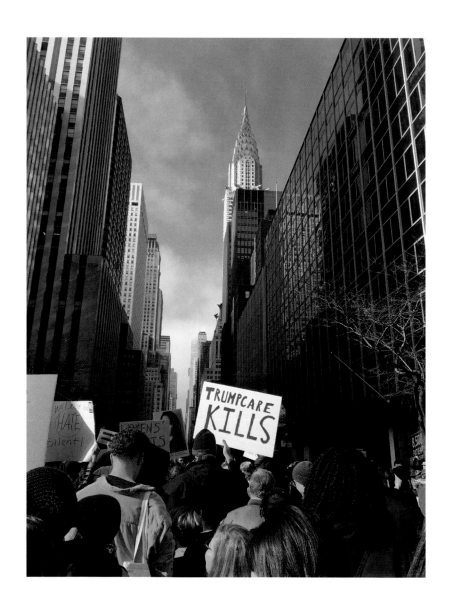

NEW YORK,

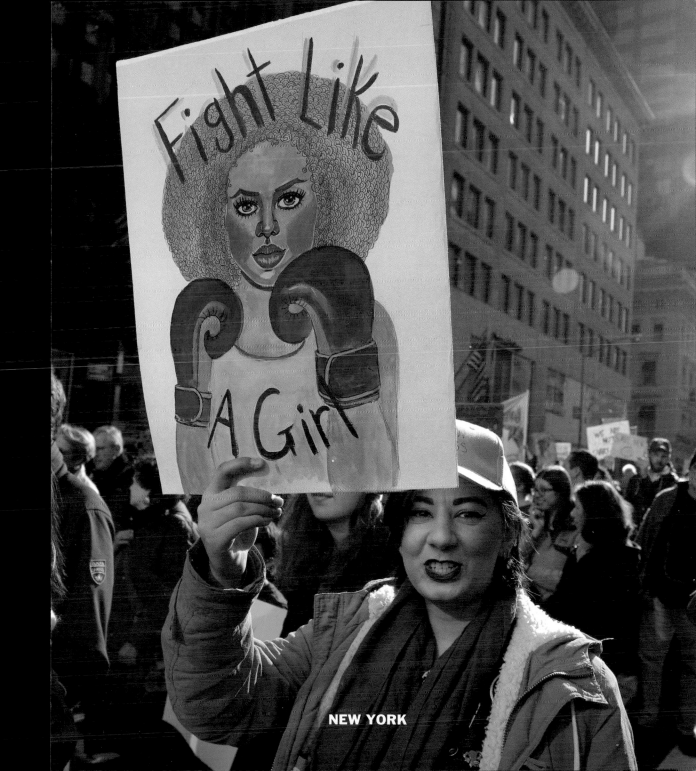

NEW YORK

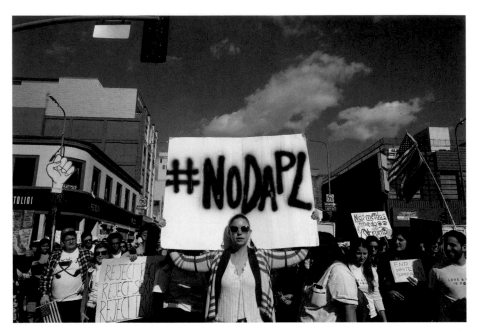

LOS ANGELES, CA

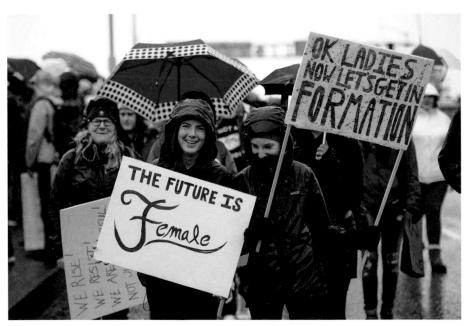

PORTLAND, OR

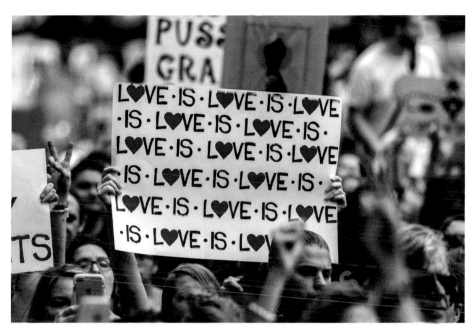

HOUSTON, TX

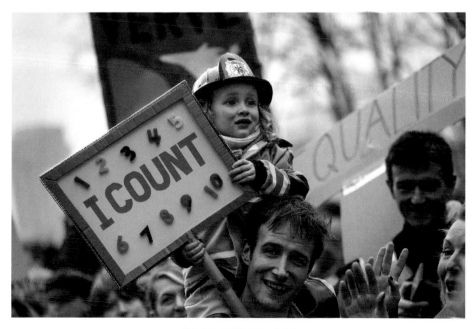

NEW YORK, NY

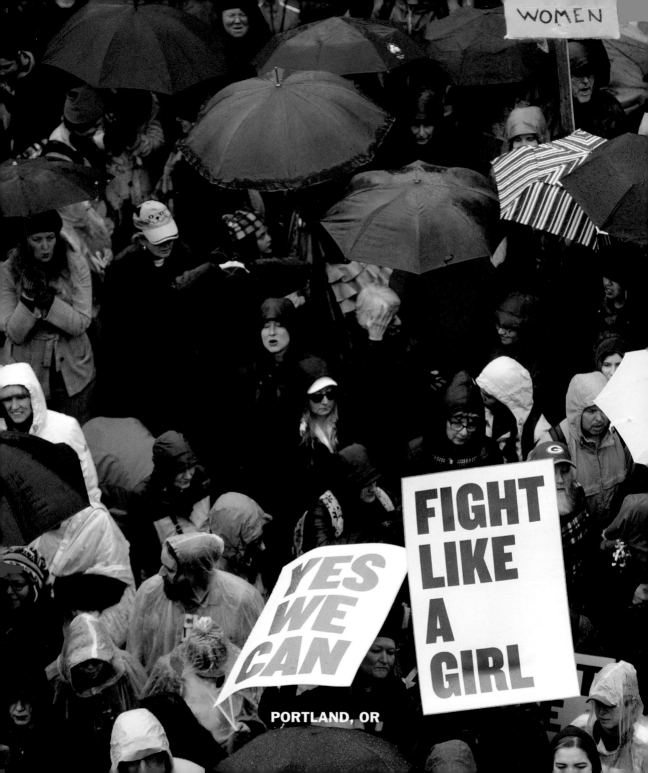

WOMEN

YES WE CAN

FIGHT LIKE A GIRL

PORTLAND, OR

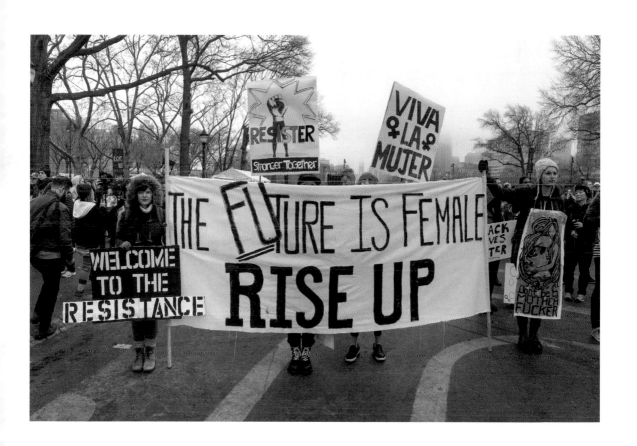

PHILADELPHIA, PA

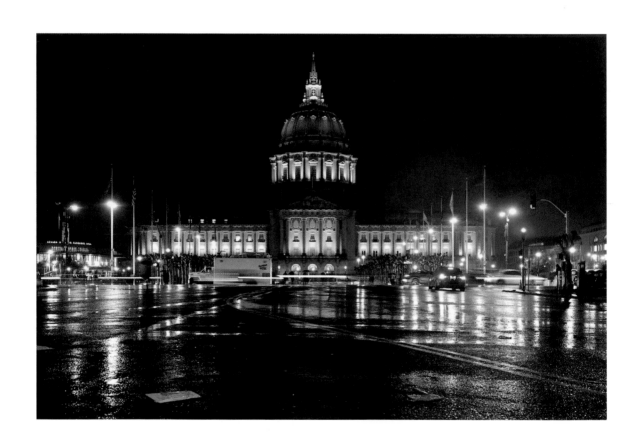

SAN FRANCISCO, CA

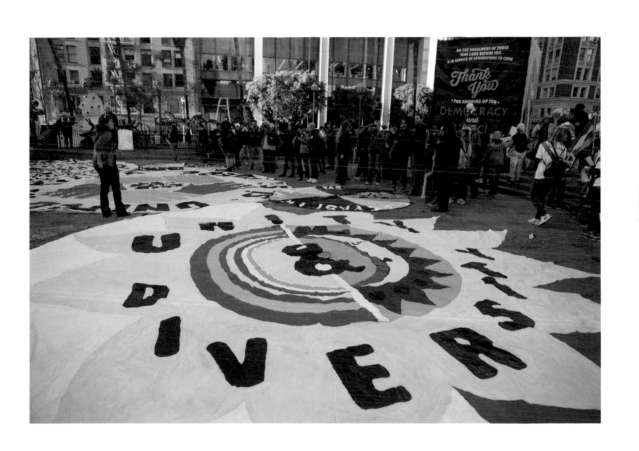

LOS ANGELES, CA

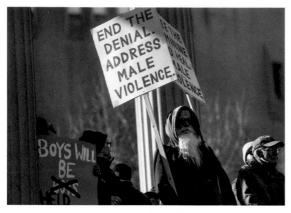

DENVER, CO

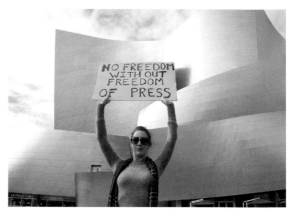

LOS ANGELES, CA

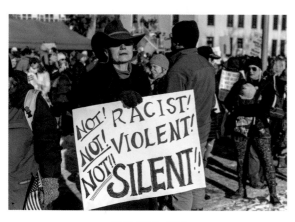

HELENA, MT

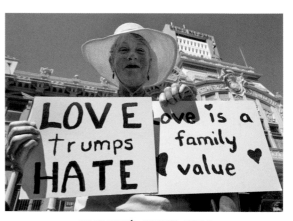

SAN JOSÉ, COSTA RICA

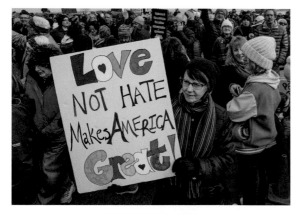

PORTLAND, ME

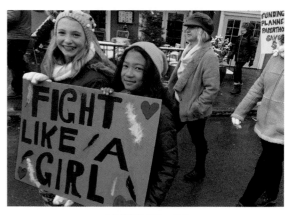

SANTA FE, NM

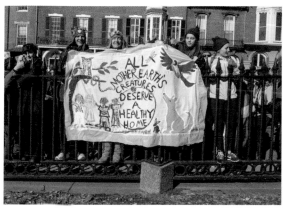

BOSTON, MA

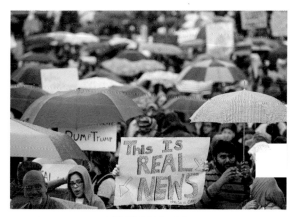

COLUMBIA, SC

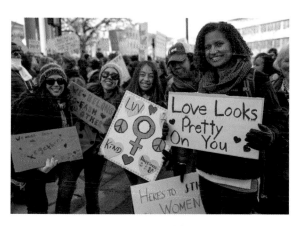

DENVER, CO

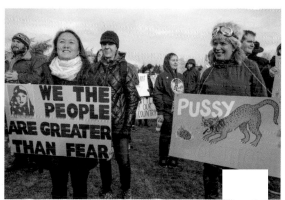

SEATTLE, WA

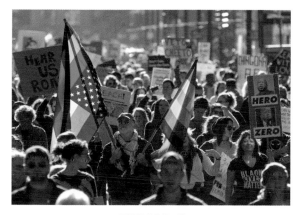

CHICAGO, IL

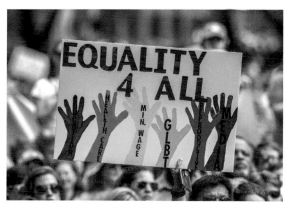

HOUSTON, TX

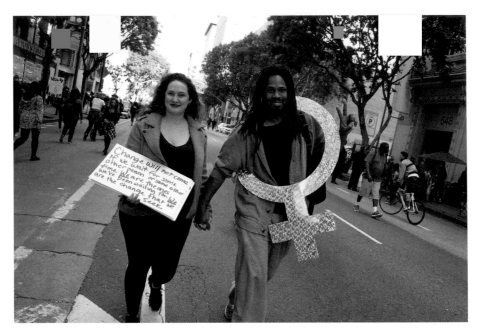

LOS ANGELES, CA

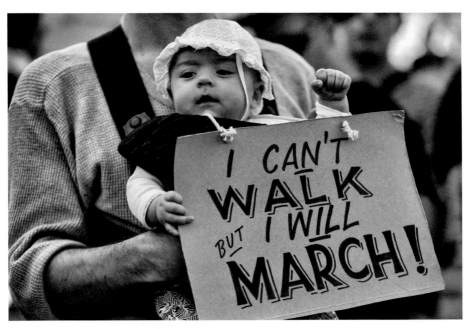

MEXICO CITY, MEXICO

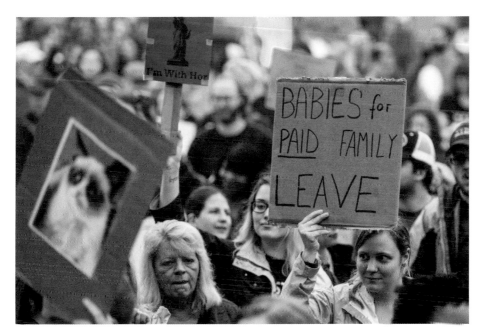

COLUMBIA, SC

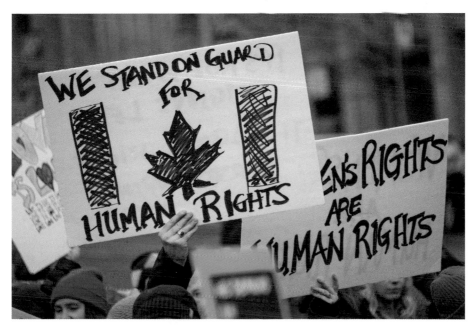

TORONTO, CANADA

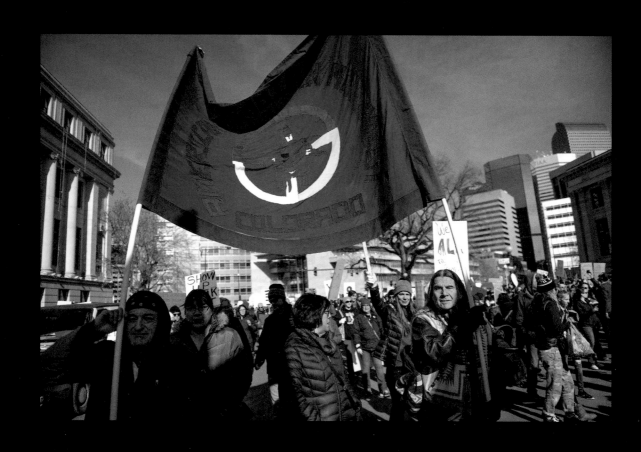

DENVER,

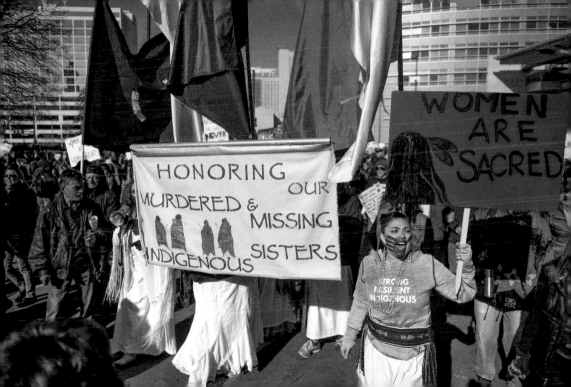

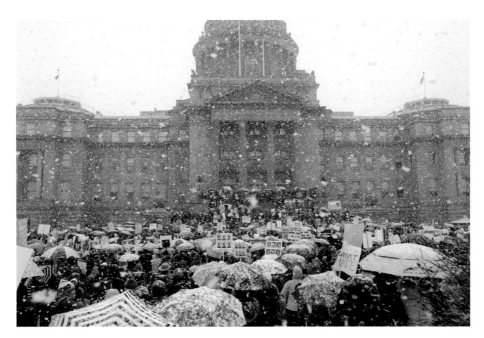

BOISE, ID

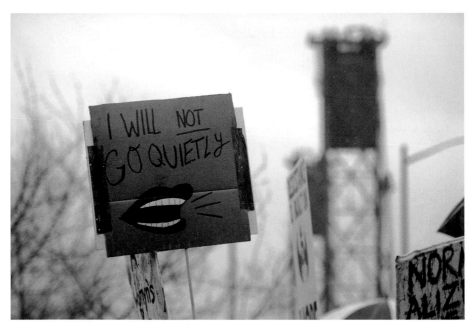

PORTLAND, OR

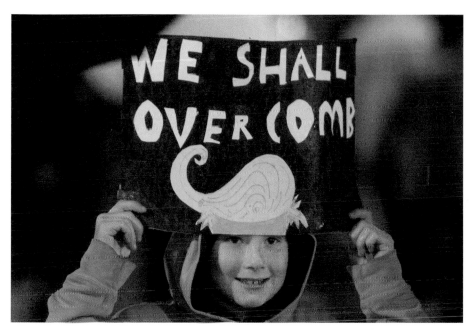

SAN FRANCISCO, CA

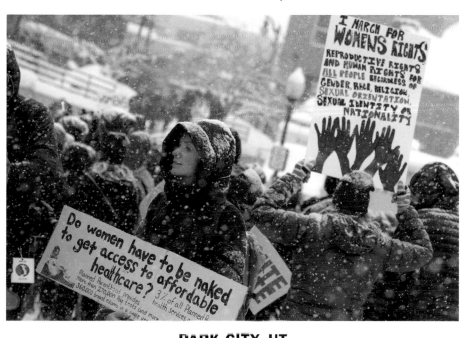

PARK CITY, UT

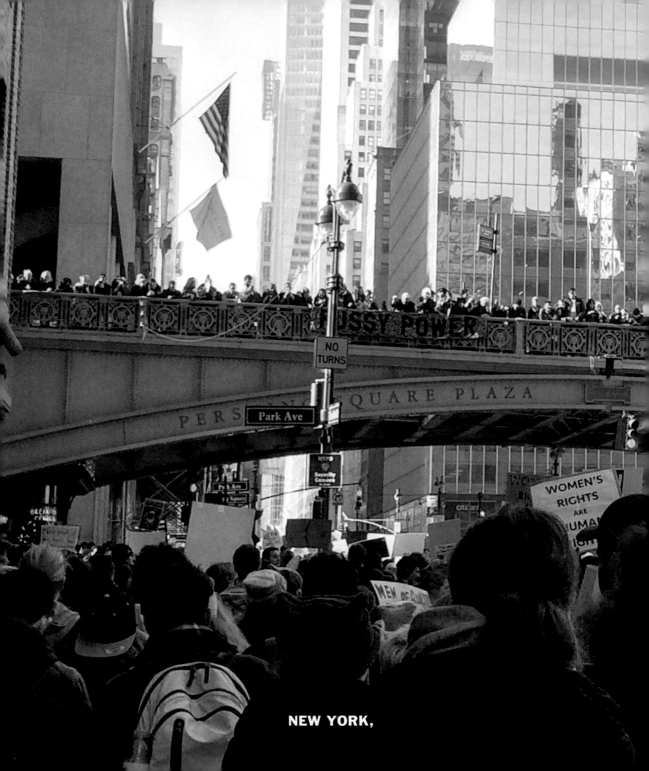

NEW YORK,

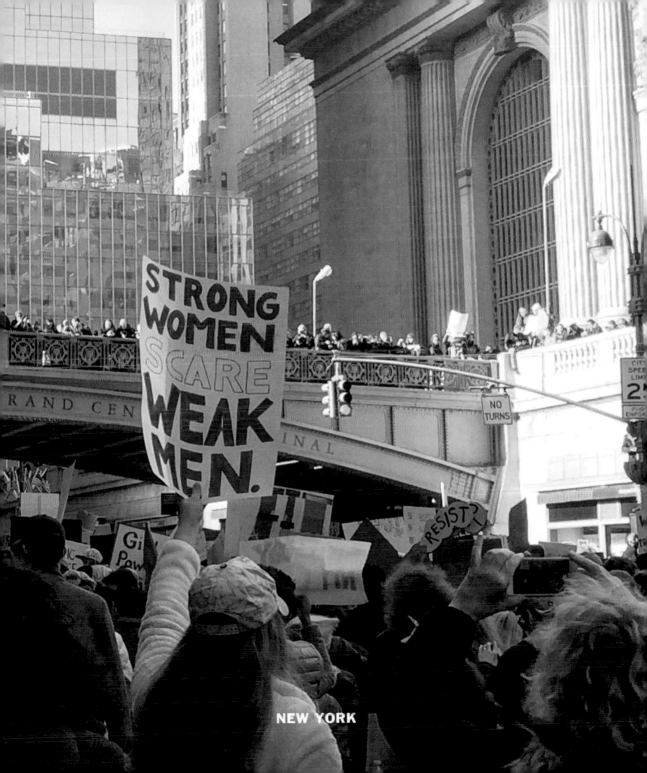

STRONG WOMEN SCARE WEAK MEN.

NEW YORK

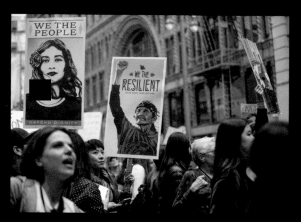
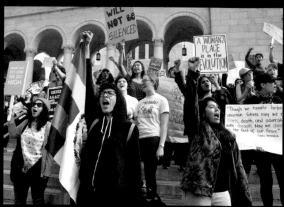
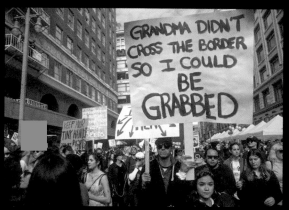
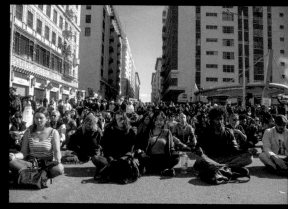
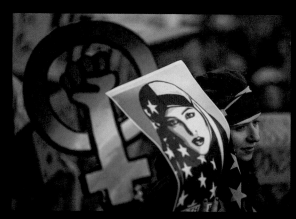
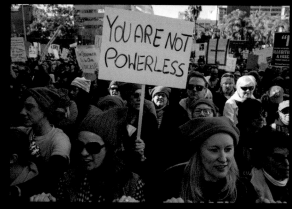

LOS ANGELES,

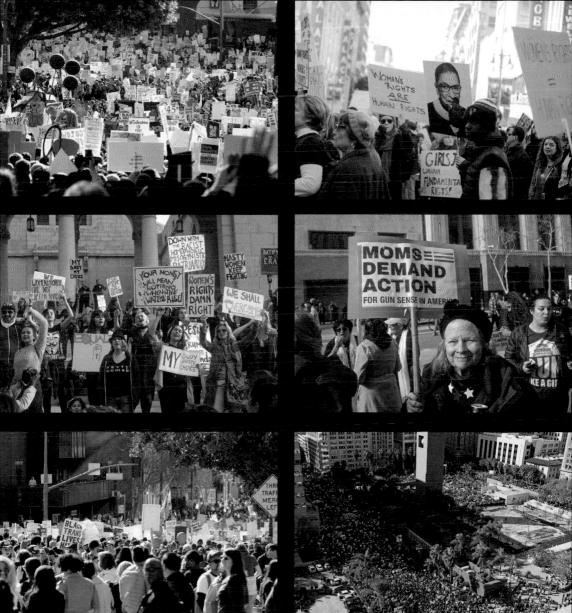

CALIFORNIA

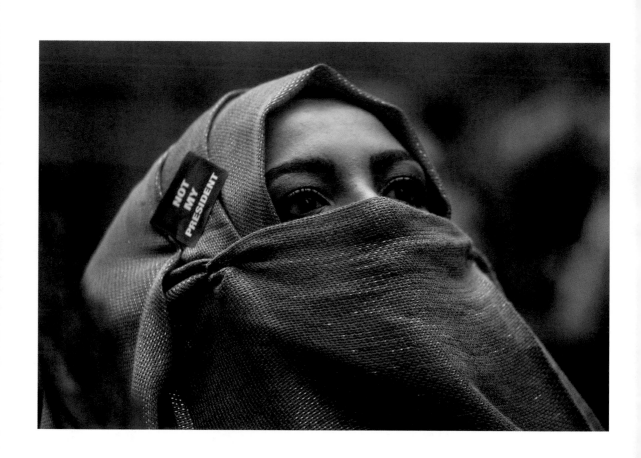

NEW YORK, NY

I AM QUEER
I WILL
NOT DISAPPEAR

HOUSTON, TX

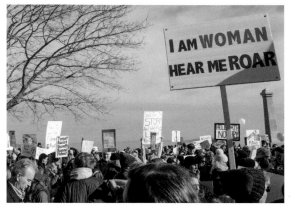

PORTLAND, ME

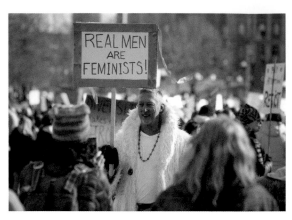

DENVER, CO

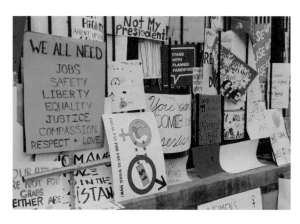

PHILADELPHIA, PA

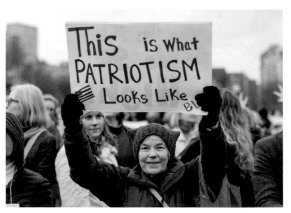

BOSTON, MA

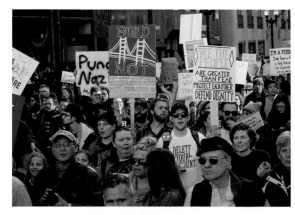

CHICAGO, IL

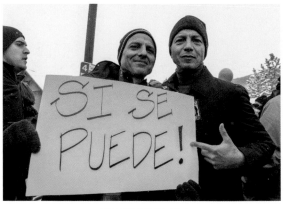

PARK CITY, UT

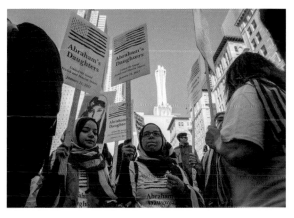

LOS ANGELES, CA

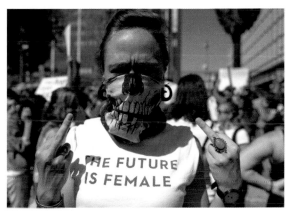

MEXICO CITY, MEXICO

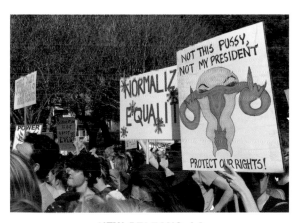

NEW ORLEANS, LA

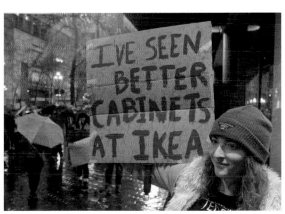

SAN FRANCISCO, CA

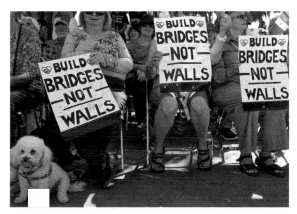

AJIJIC, MEXICO

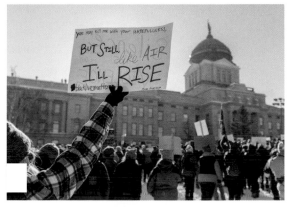

HELENA, MT

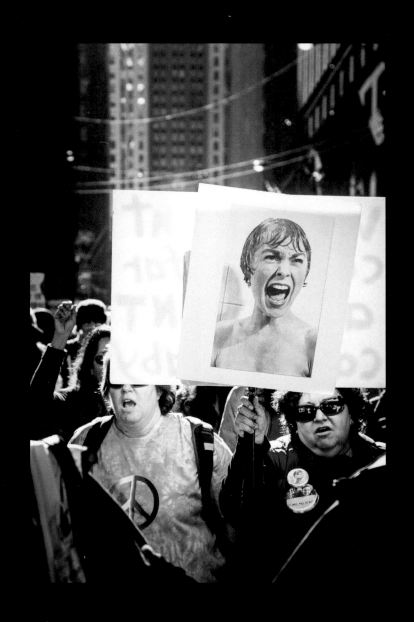

CHICAGO,

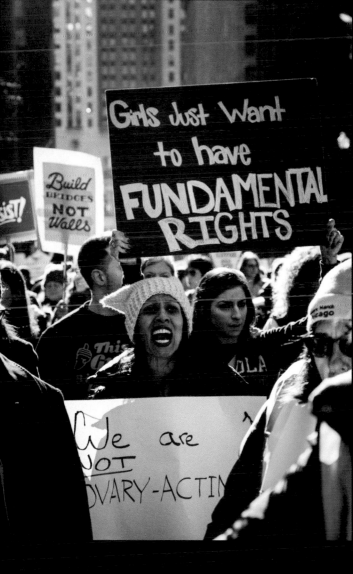

ILLINOIS

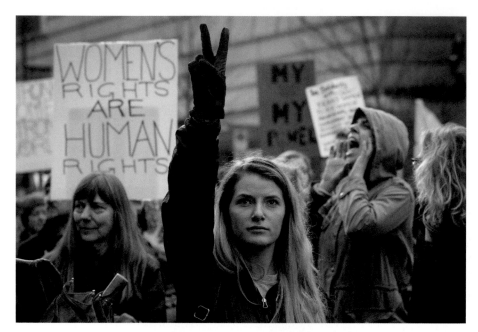

VANCOUVER, CANADA

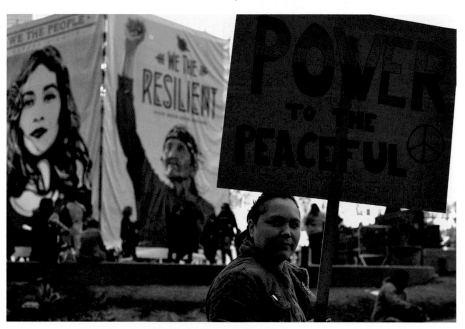

LOS ANGELES, CA

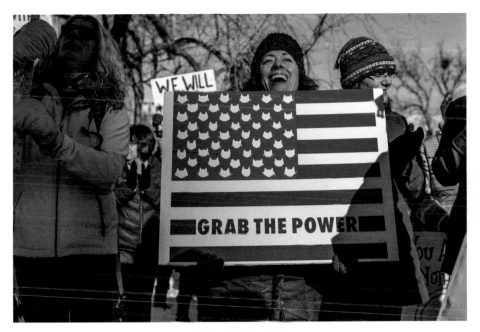

HELENA, MT

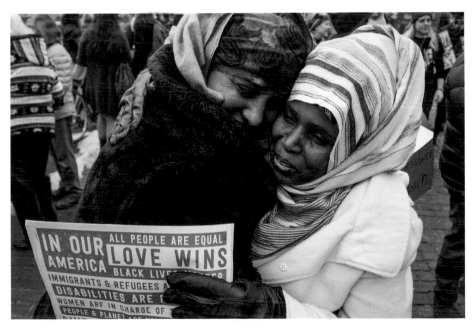

PORTLAND, ME

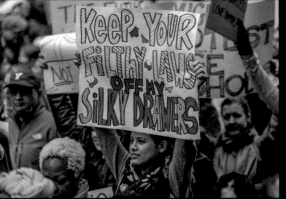
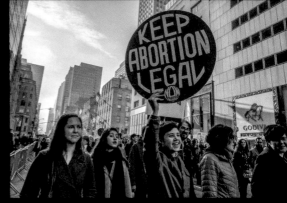
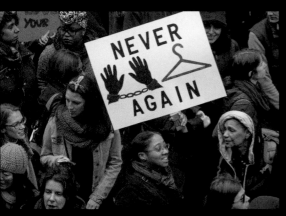
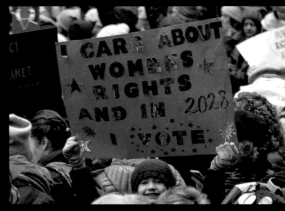
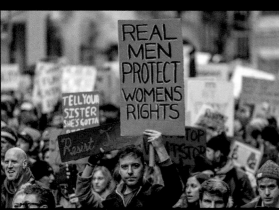
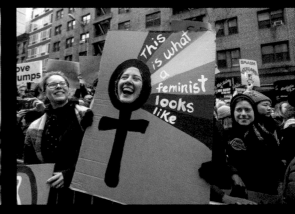

NEW YORK,

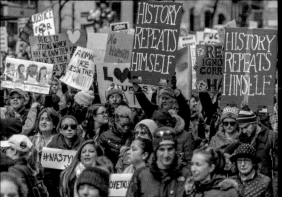

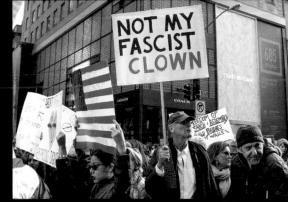

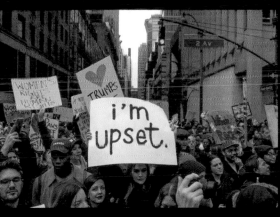

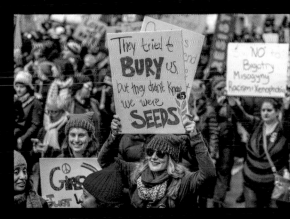

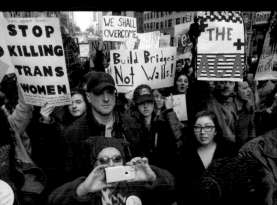

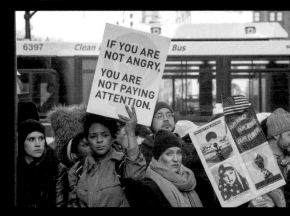

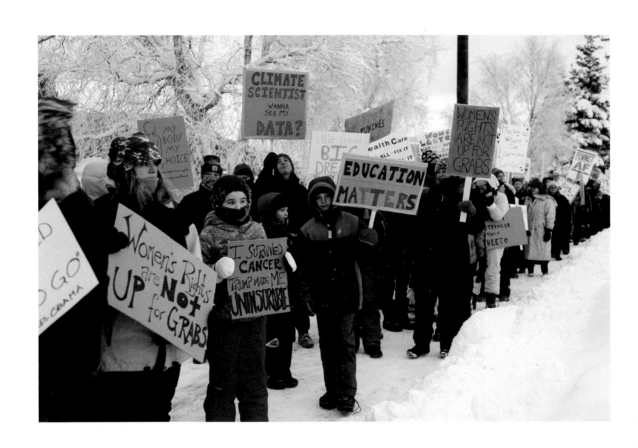

FAIRBANKS, AK

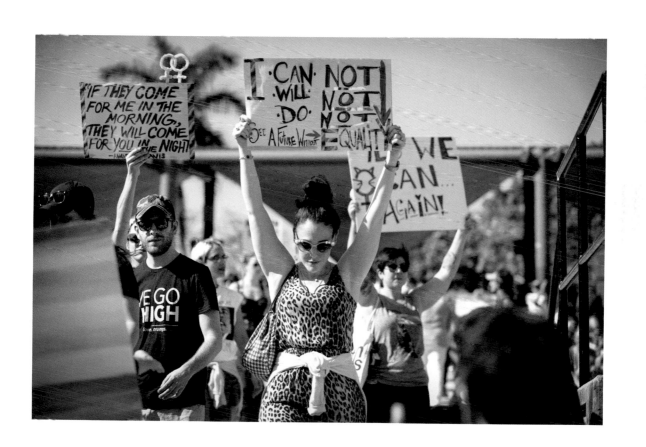

MIAMI, FL

SHOW ME WHAT DEMOCRACY LOOKS LIKE

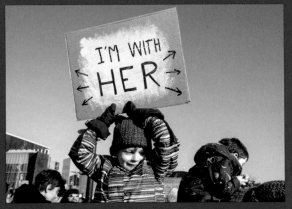

AMSTERDAM, THE NETHERLANDS

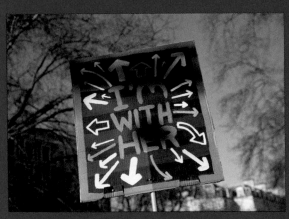

LONDON, ENGLAND

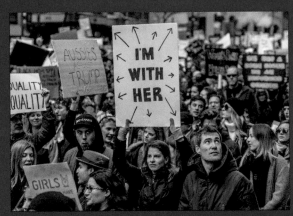

NEW YORK, NY

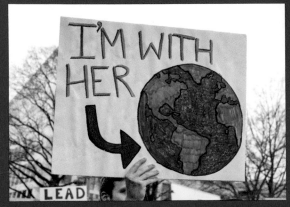

WASHINGTON, D.C.

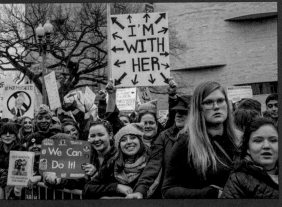

WASHINGTON, D.C.

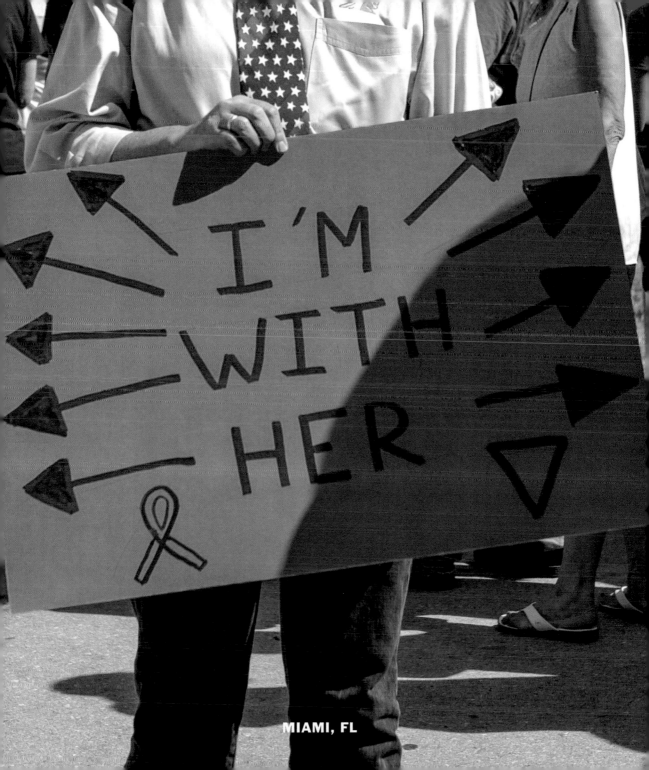

MIAMI, FL

SOU
AME

ARGENTINA, ARUBA, BOLIVIA, BRAZIL, CARIBBEAN NETHERLANDS, CHILE, COLOMBIA,

UTH
RICA

ECUADOR, GUATEMALA, MAURITIUS,
NICARAGUA, PERU, URUGUAY

95

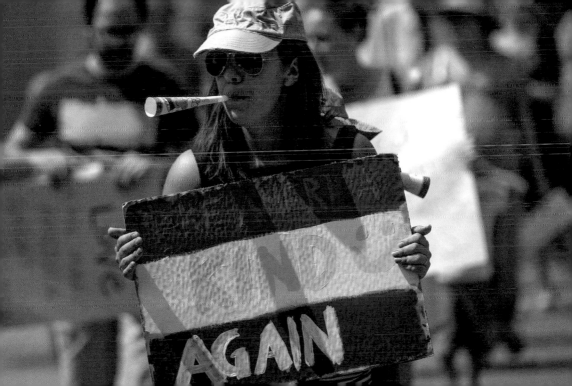

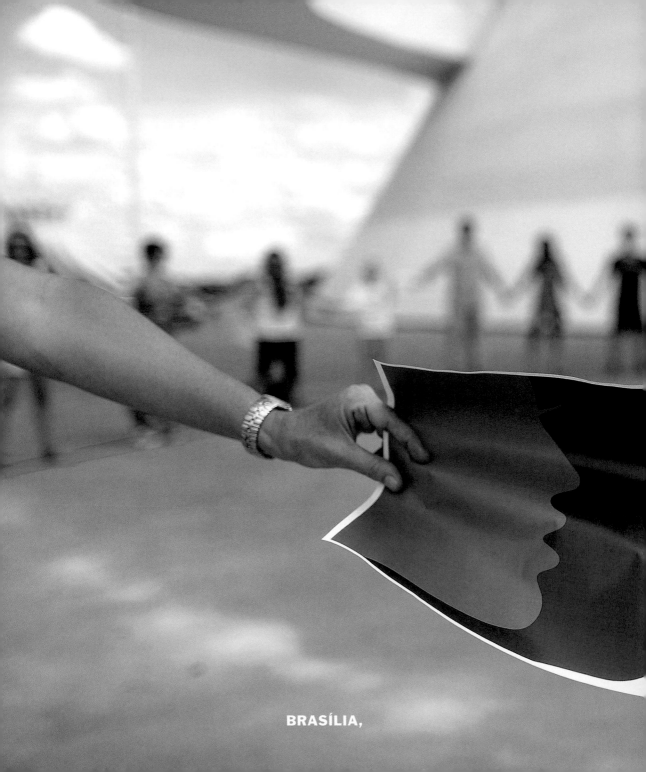

BRASÍLIA,

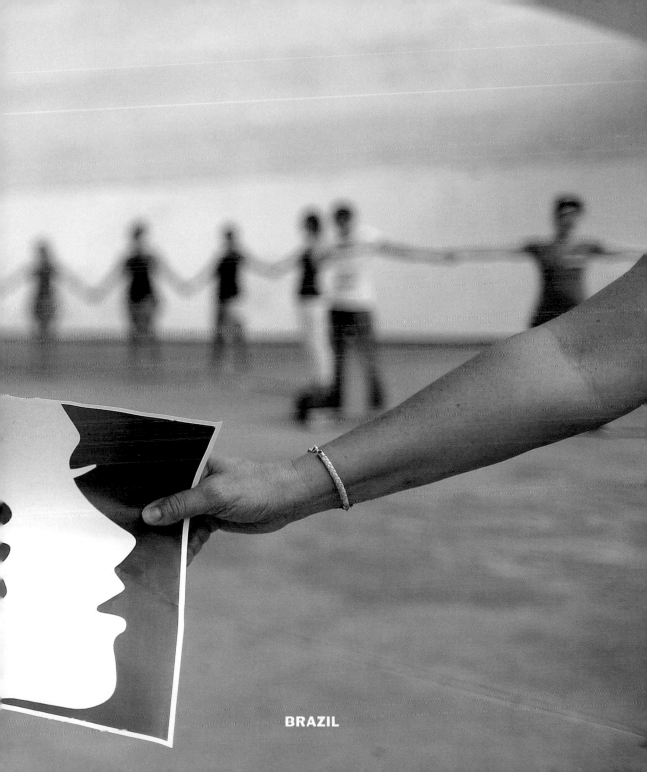

BRAZIL

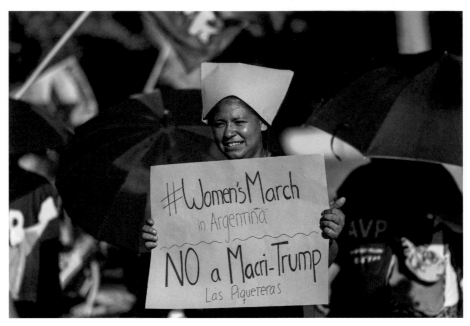

BUENOS AIRES, ARGENTINA

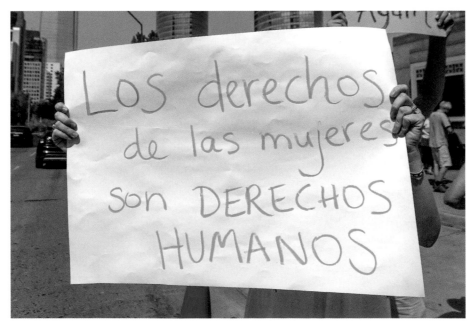

SANTIAGO, CHILE

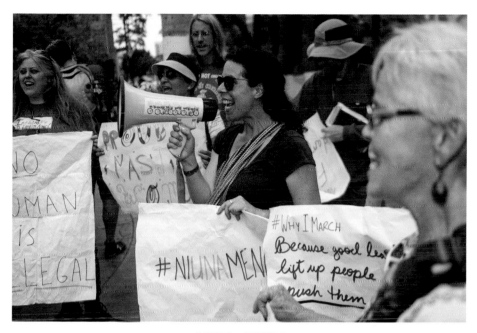

LIMA, PERU

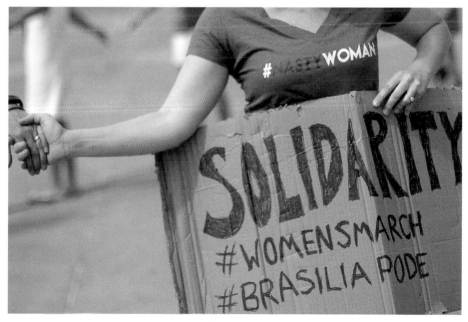

BRASÍLIA, BRAZIL

THIS IS WHAT DEMOCRACY LOOKS LIKE

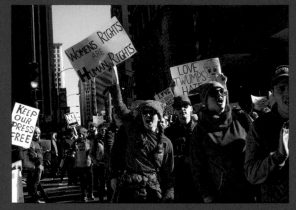

CHICAGO, IL

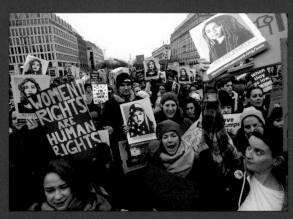

BERLIN, GERMANY

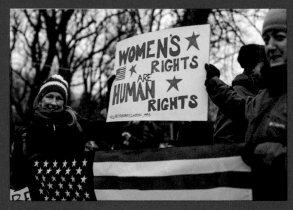

WARSAW, POLAND

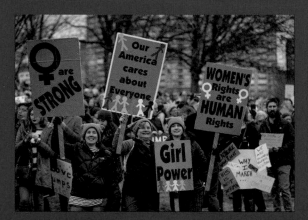

BOSTON, MA

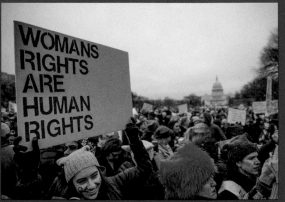

WASHINGTON, D.C.

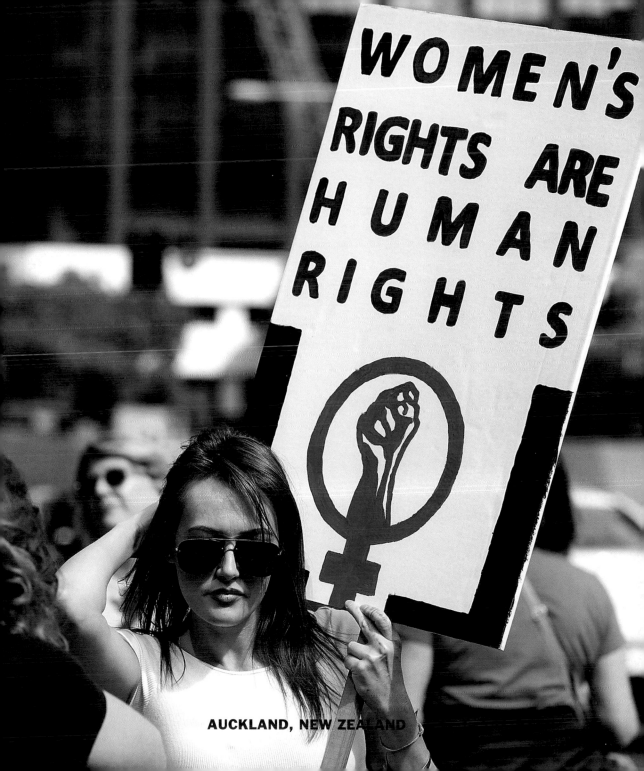

WOMEN'S RIGHTS ARE HUMAN RIGHTS

AUCKLAND, NEW ZEALAND

AFR

BOTSWANA, CONGO, GHANA, KENYA, LIBERIA, MADAGASCAR, MALAWI,

RICA

NIGERIA, RWANDA, SOUTH AFRICA, TANZANIA, ZAMBIA, ZIMBABWE

105

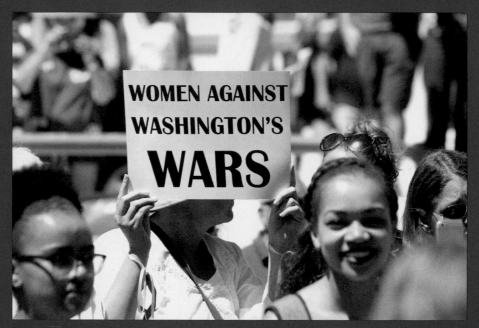

CAPE TOWN, SOUTH AFRICA

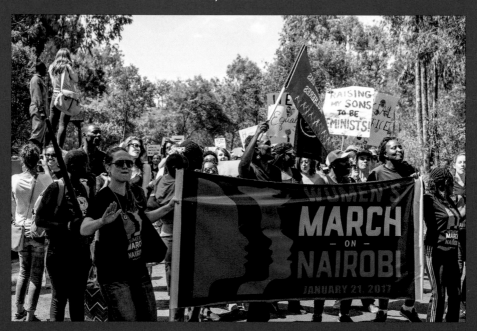

NAIROBI, KENYA

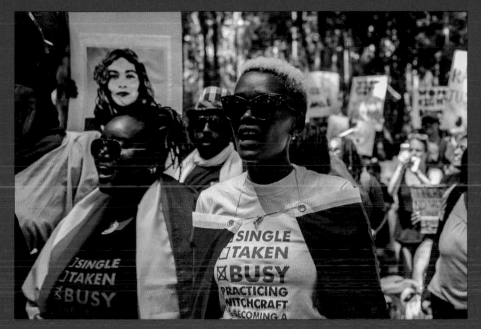

NAIROBI, KENYA

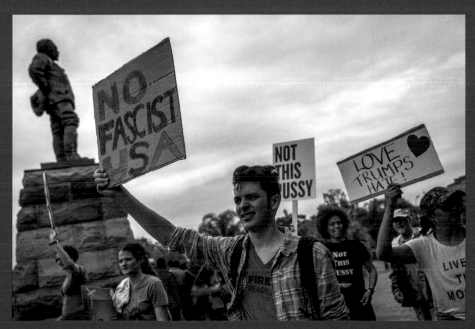

DURBAN, SOUTH AFRICA

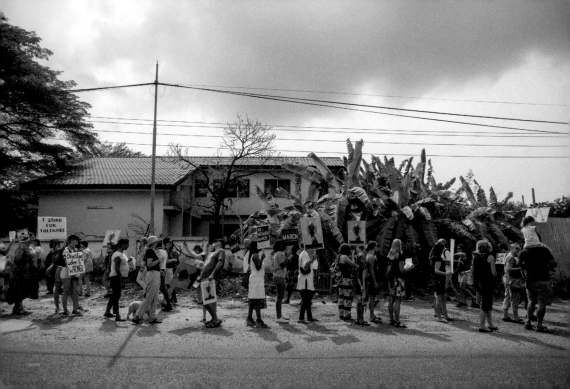

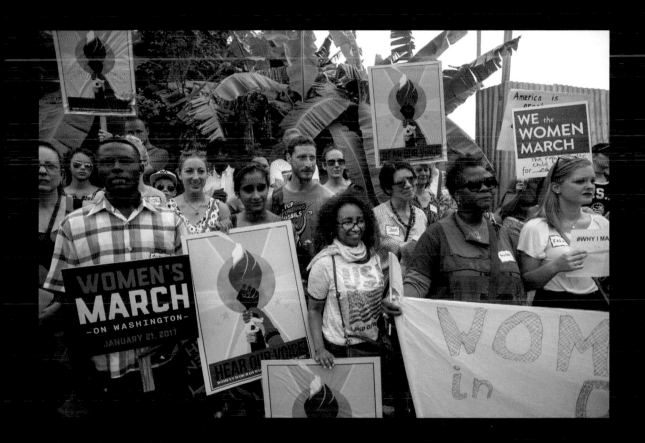

GHANA

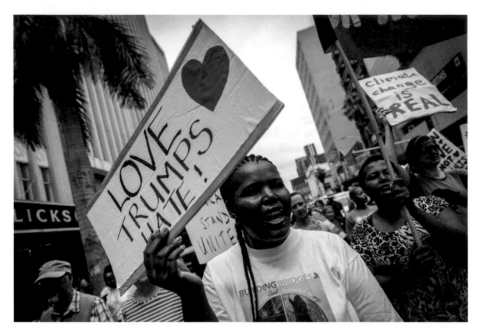

DURBAN, SOUTH AFRICA

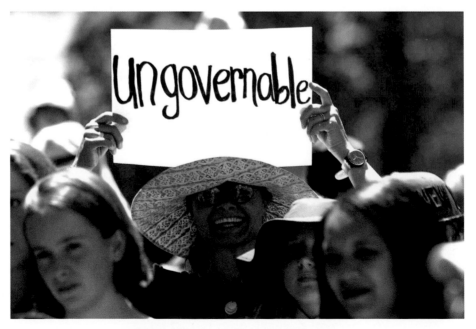

CAPE TOWN, SOUTH AFRICA

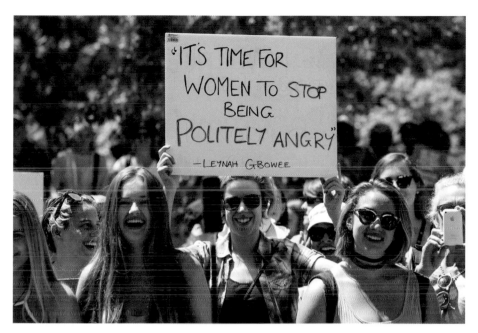

CAPE TOWN, SOUTH AFRICA

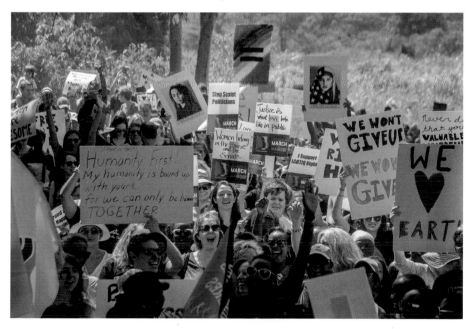

NAIROBI, KENYA

THEY TRIED TO BURY US, BUT THEY DIDN'T KNOW WE WERE SEEDS

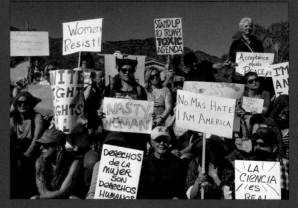

AJIJIC, MEXICO

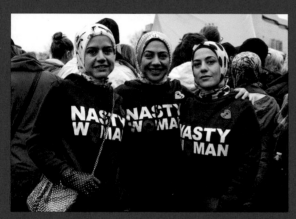

WASHINGTON, D.C.

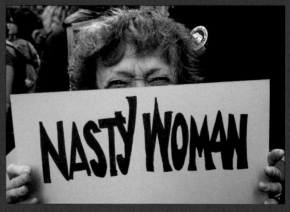

NEW YORK, NY

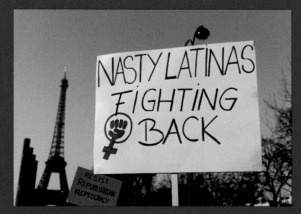

PARIS, FRANCE

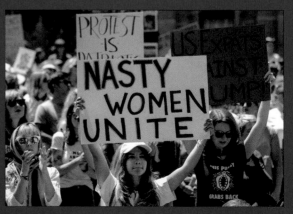

MELBOURNE, AUSTRALIA

THE LADYBIRD BOOK OF

NASTY
WOMEN

LONDON, ENGLAND

EUR

AUSTRIA, **BELARUS**, **BELGIUM**, BULGARIA,
CZECH REPUBLIC, DENMARK, ENGLAND, **FINLAND**,
FRANCE, GEORGIA, GERMANY,
GREECE, HUNGARY, **ICELAND**, IRELAND, ITALY,

OPE

KOSOVO, LATVIA, LITHUANIA, THE NETHERLANDS, NORWAY, POLAND, PORTUGAL, ROMANIA, RUSSIA, SCOTLAND, SERBIA, SLOVAKIA, SLOVENIA, SPAIN, SWEDEN, SWITZERLAND, WALES

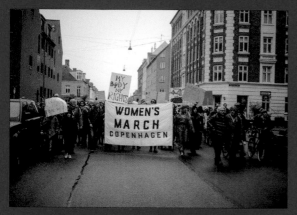

COPENHAGEN, DENMARK

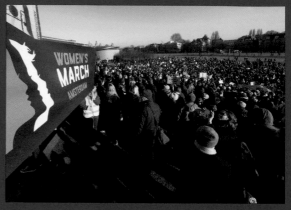

AMSTERDAM, THE NETHERLANDS

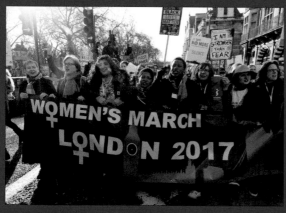

LONDON, ENGLAND

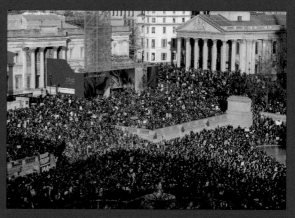

LONDON, ENGLAND

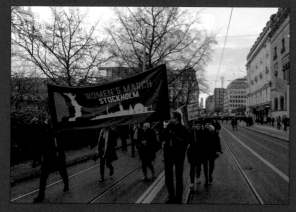

STOCKHOLM, SWEDEN

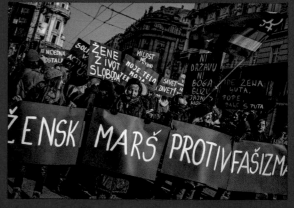

BELGRADE, SERBIA

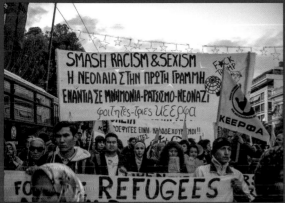

ATHENS, GREECE

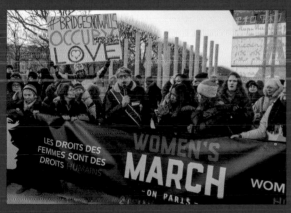

PARIS, FRANCE

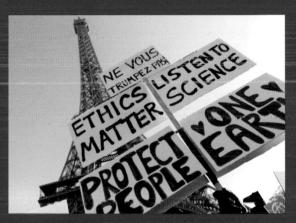

PARIS, FRANCE

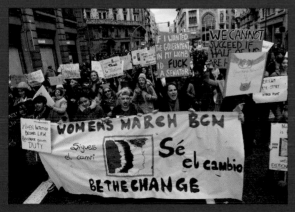

BARCELONA, SPAIN

SOFIA, BULGARIA

DUBLIN, IRELAND

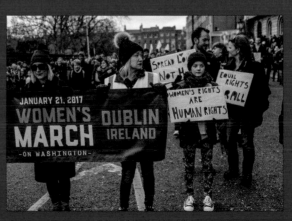

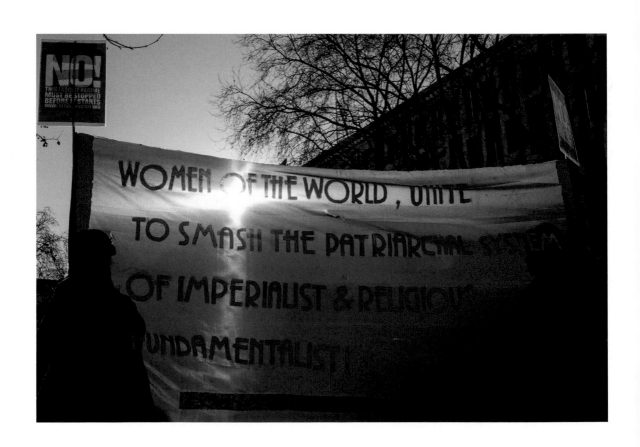

LONDON, ENGLAND

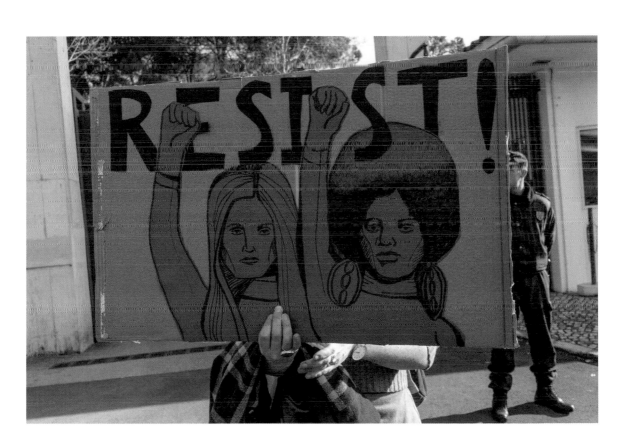

LISBON, PORTUGAL

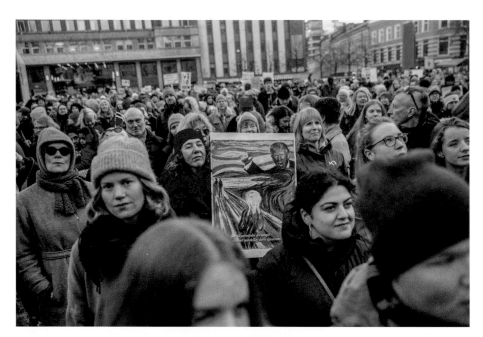

OSLO, NORWAY

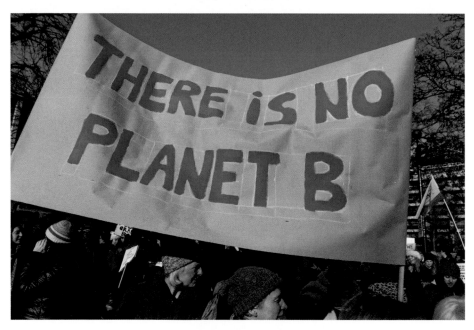

PARIS, FRANCE

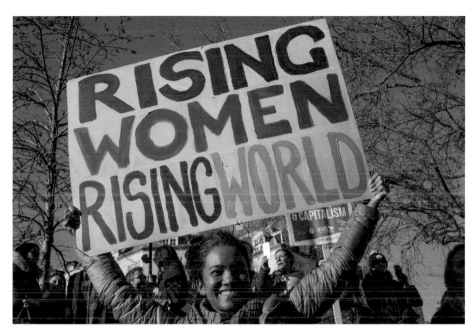

LONDON, ENGLAND

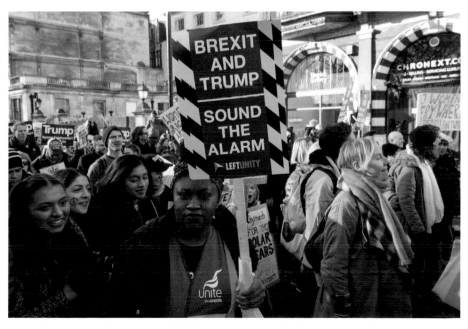

LONDON, ENGLAND

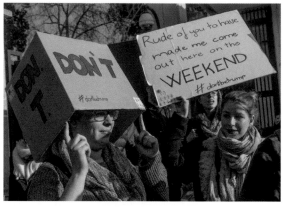

LISBON, PORTUGAL

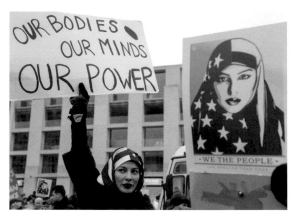

BERLIN, GERMANY

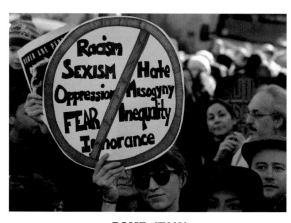

ROME, ITALY

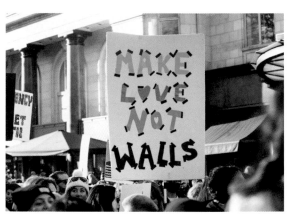

LONDON, ENGLAND

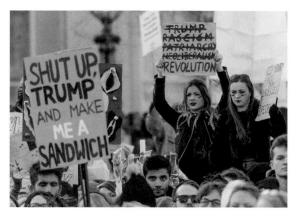

LONDON, ENGLAND

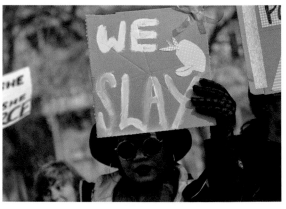

BUDAPEST, HUNGARY

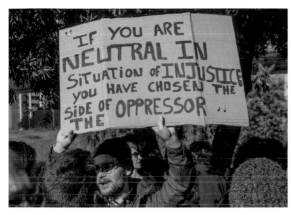

LISBON, PORTUGAL

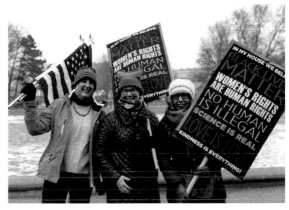

VIENNA, AUSTRIA

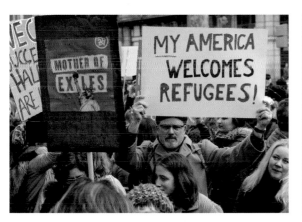

BARCELONA, SPAIN

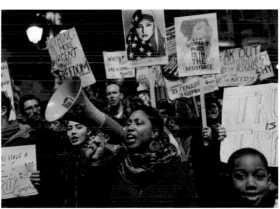

ATHENS, GREECE

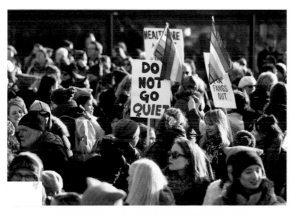

AMSTERDAM, THE NETHERLANDS

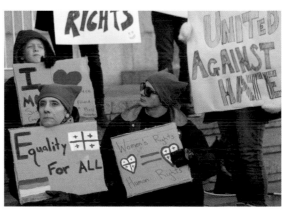

TBILISI, GEORGIA

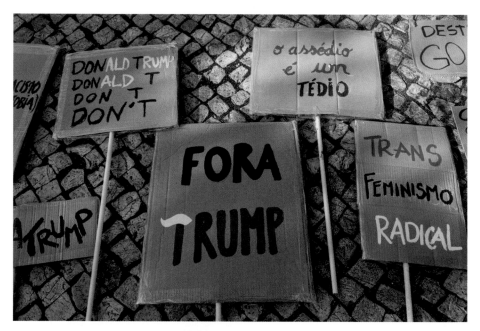

LISBON, PORTUGAL

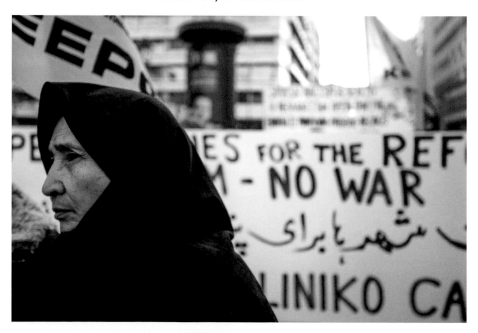

ATHENS, GREECE

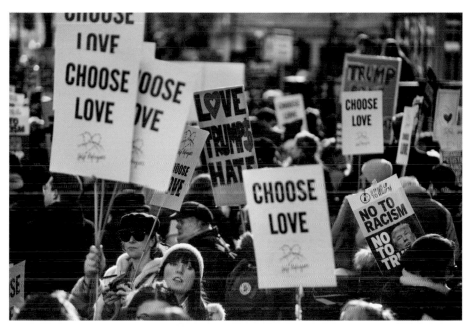

LONDON, ENGLAND

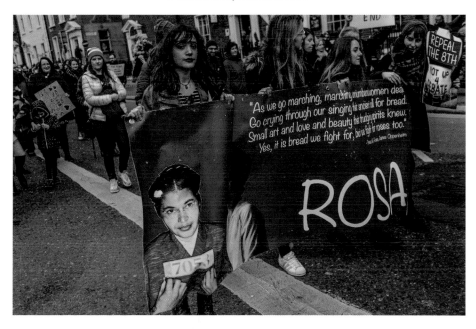

DUBLIN, IRELAND

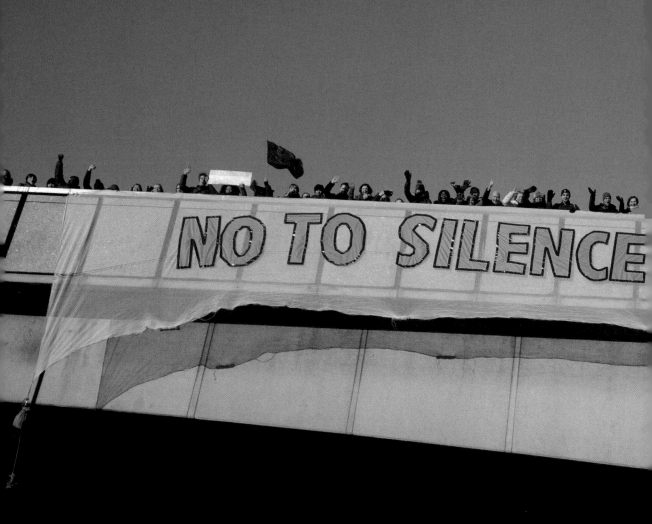

LONDON,

ENGLAND

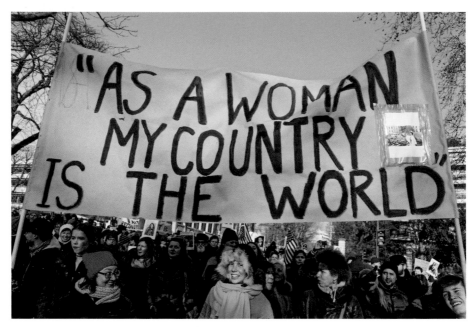

PARIS, FRANCE

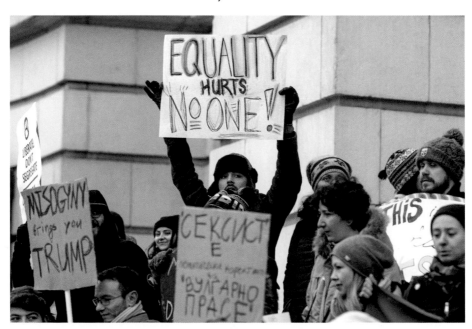

SOFIA, BULGARIA

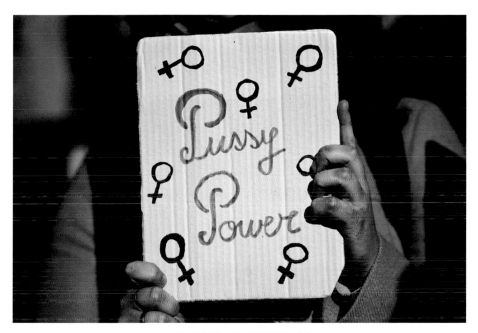

LISBON, PORTUGAL

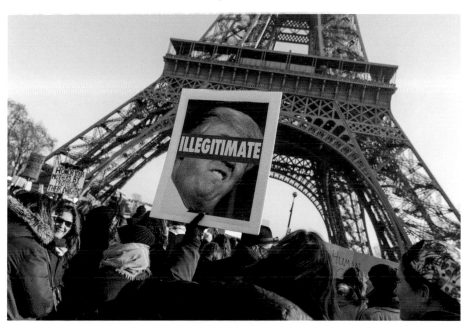

PARIS, FRANCE

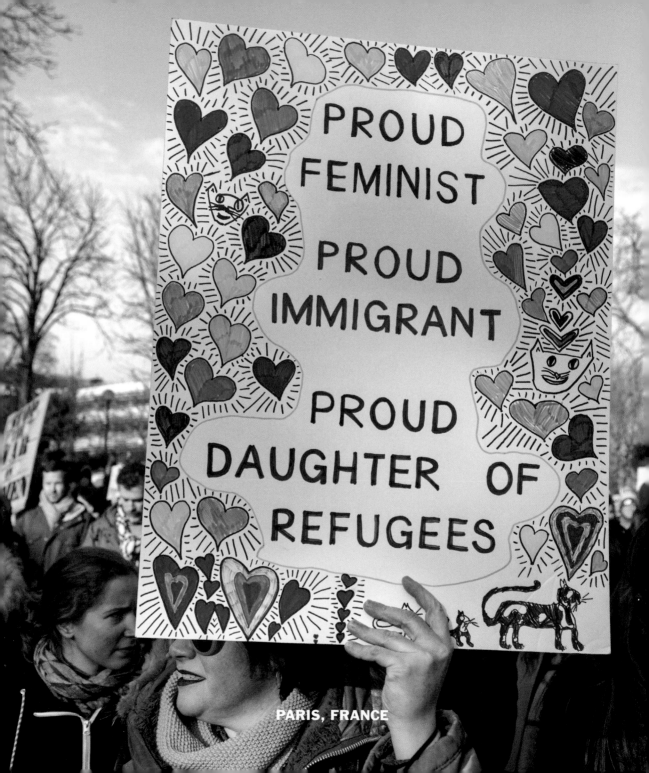

PROUD FEMINIST

PROUD IMMIGRANT

PROUD DAUGHTER OF REFUGEES

PARIS, FRANCE

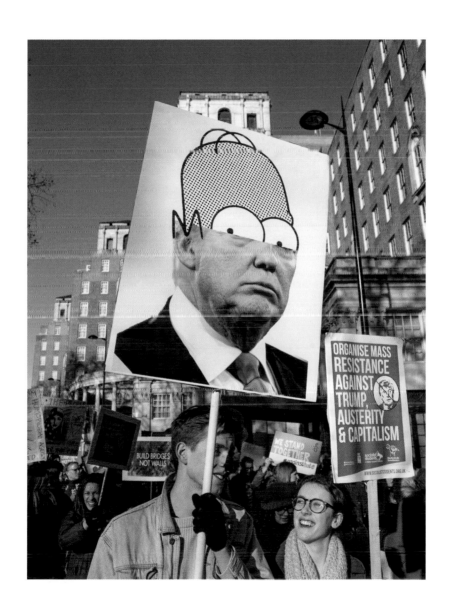

LONDON, ENGLAND

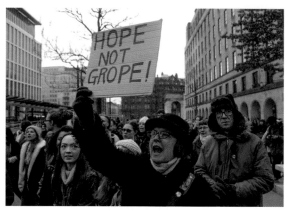

MANCHESTER, ENGLAND

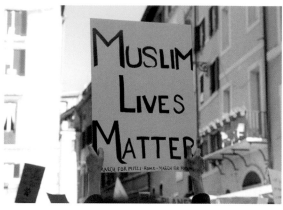

ROME, ITALY

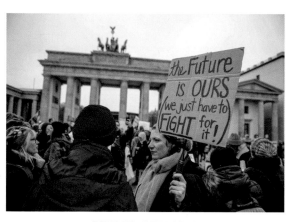

BERLIN, GERMANY

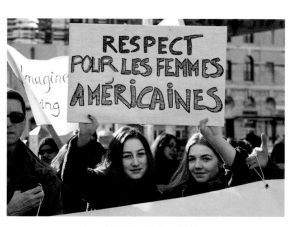

MARSEILLE, FRANCE

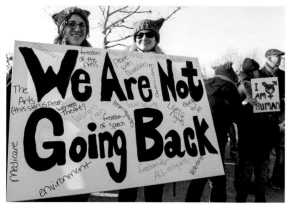

AMSTERDAM, THE NETHERLANDS

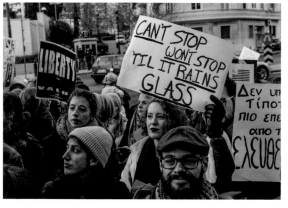

ATHENS, GREECE

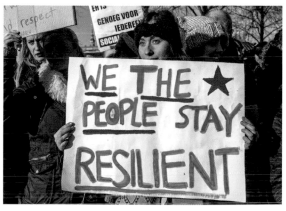

AMSTERDAM, THE NETHERLANDS

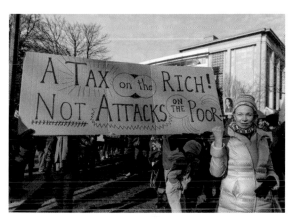

PARIS, FRANCE

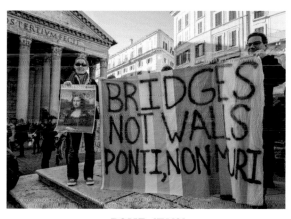

ROME, ITALY

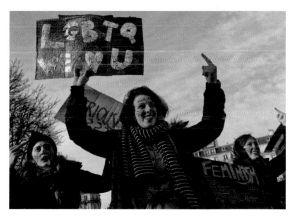

PARIS, FRANCE

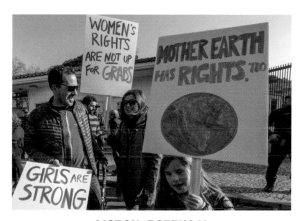

LISBON, PORTUGAL

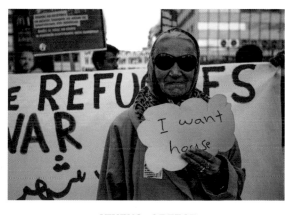

ATHENS, GREECE

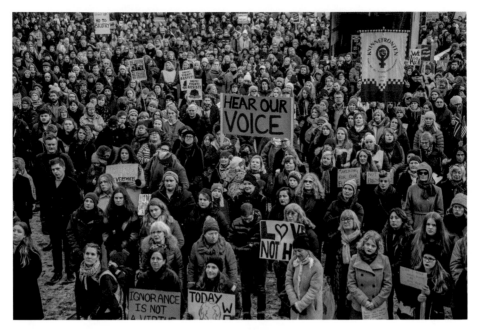

OSLO, NORWAY

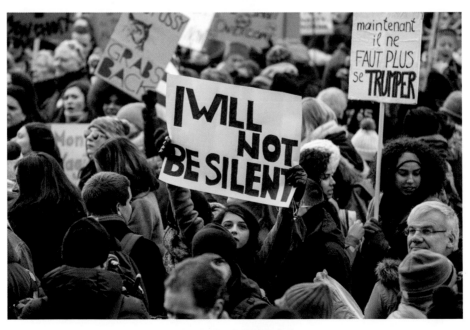

PARIS, FRANCE

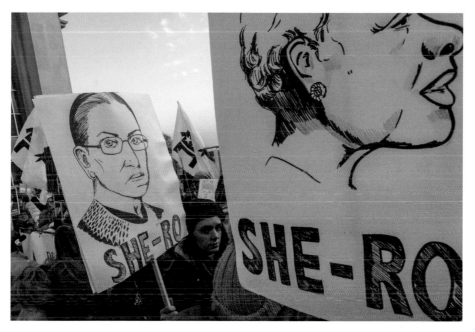

PARIS, FRANCE

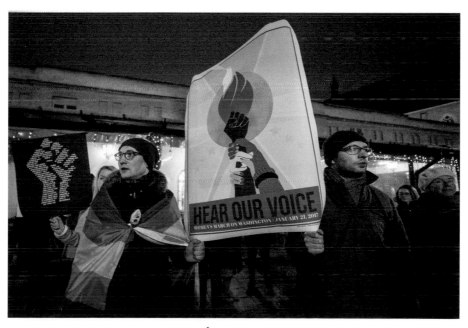

KRAKÓW, POLAND

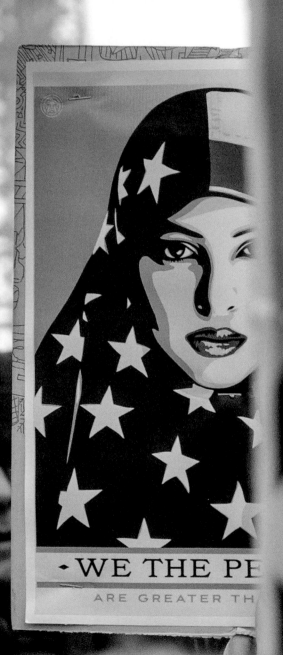

PARIS,

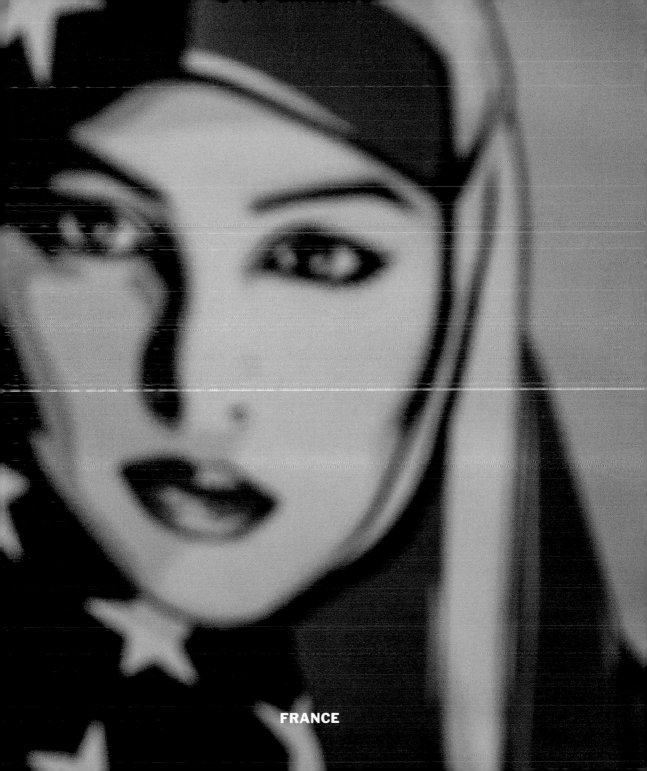

FRANCE

BUILD BRIDGES, NOT WALLS

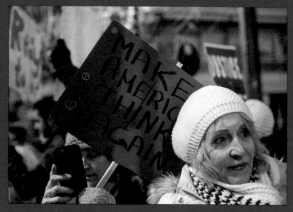

ATHENS, GREECE

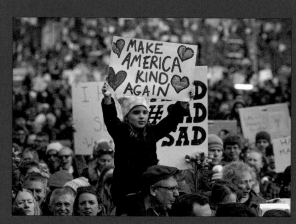

BOSTON, MA

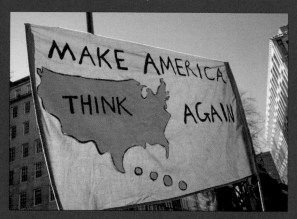

LONDON, ENGLAND

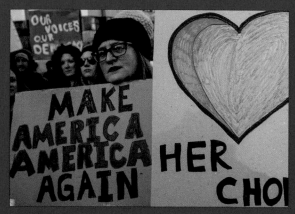

PRAGUE, CZECH REPUBLIC

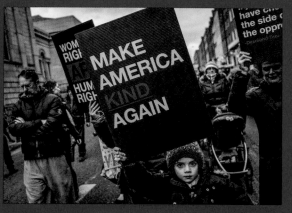

DUBLIN, IRELAND

**INDIA, INDONESIA, IRAQ, ISRAEL, JAPAN,
LEBANON, MYANMAR (BURMA),**

MACAU, SAUDI ARABIA, SINGAPORE, SOUTH KOREA, THAILAND, VIETNAM

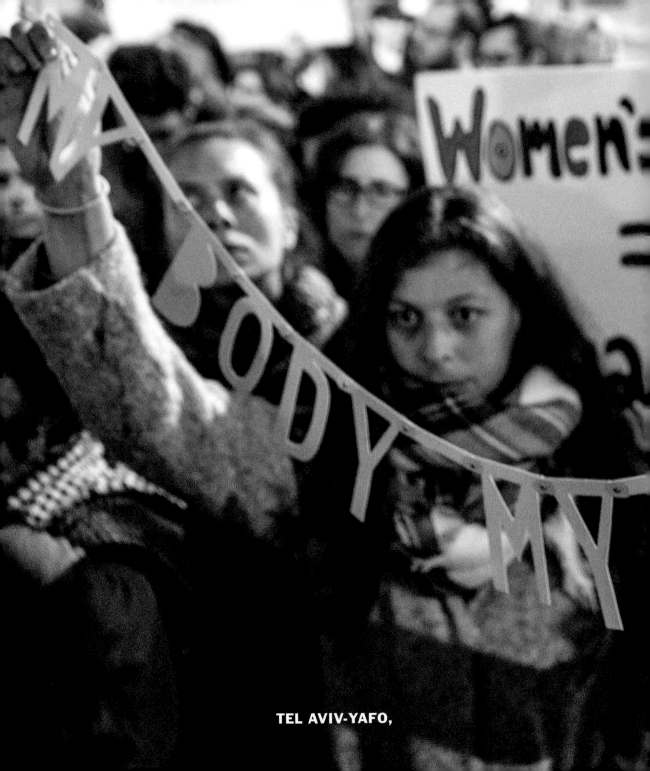

TEL AVIV-YAFO,

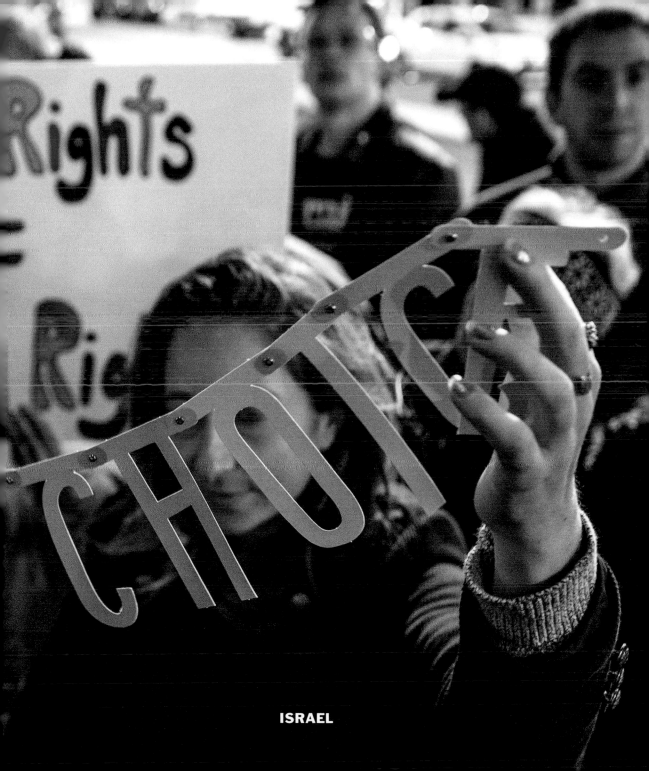

ISRAEL

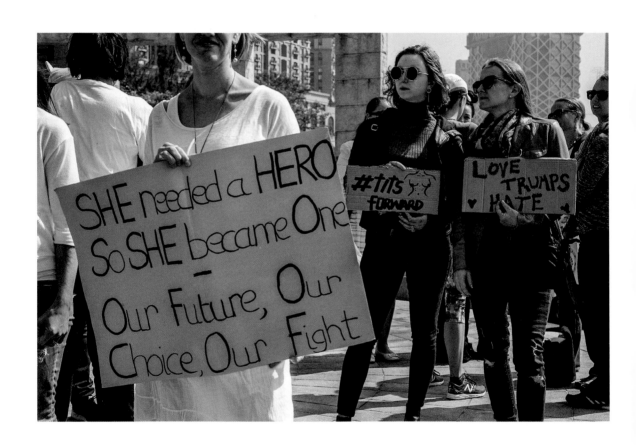

TAIPA, MACAU

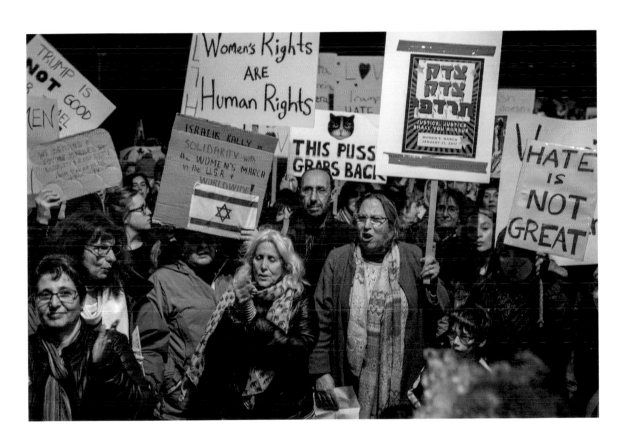

TEL AVIV-YAFO, ISRAEL

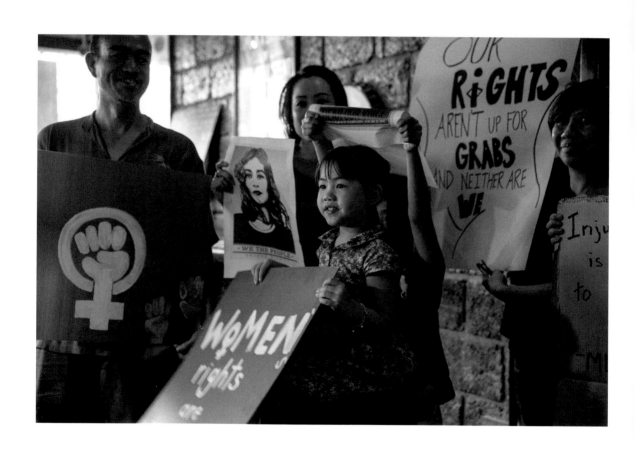

BANGKOK, THAILAND

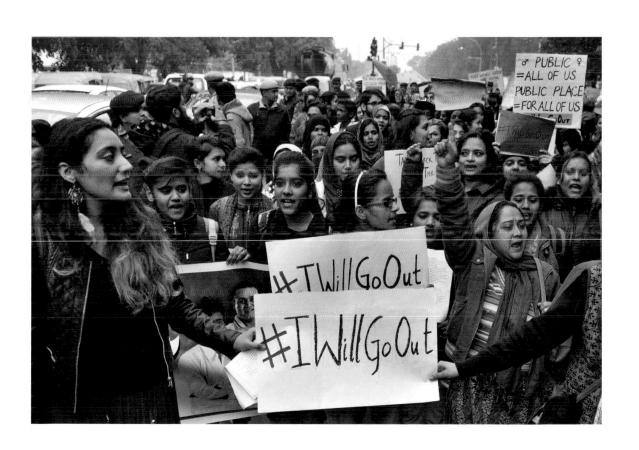

NEW DELHI, INDIA

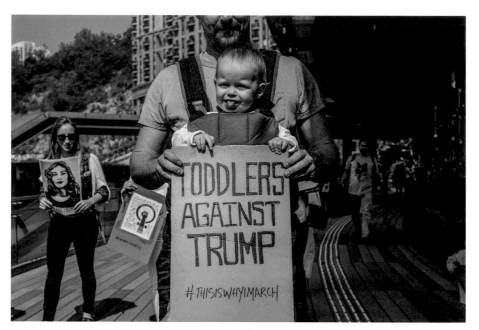

TAIPA, MACAU

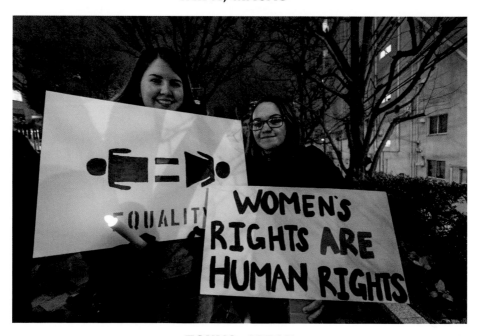

TOKYO, JAPAN

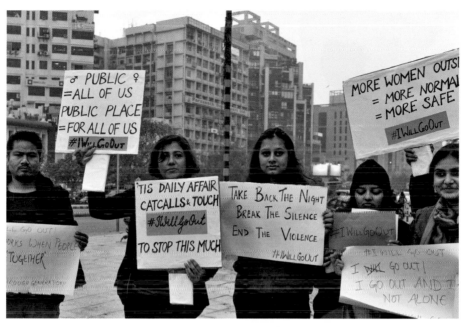

NEW DELHI, INDIA

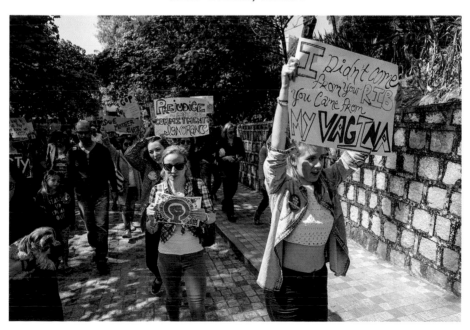

TAIPA, MACAU

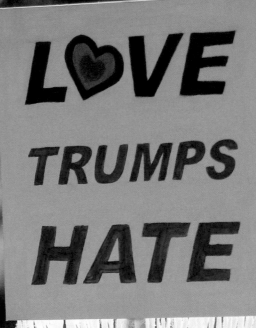

LOVE TRUMPS HATE

MELBOURNE, AUSTRALIA

LOVE
IS
LOVE
IS
LOVE
IS
LOVE
IS
LOVE

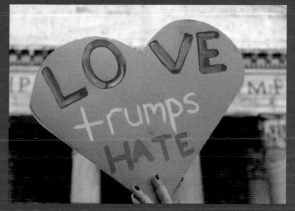

ROME, ITALY

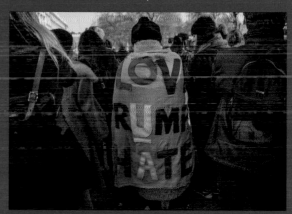

LONDON, ENGLAND

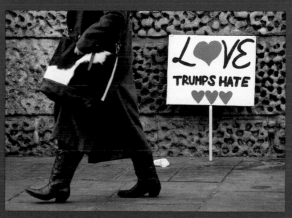

LONDON, ENGLAND

AUSTR
NEW ZE

ALIA &
ALAND

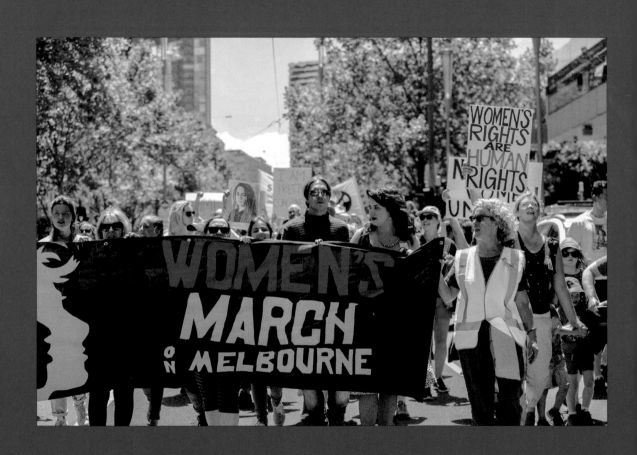

MELBOURNE, AUSTRALIA

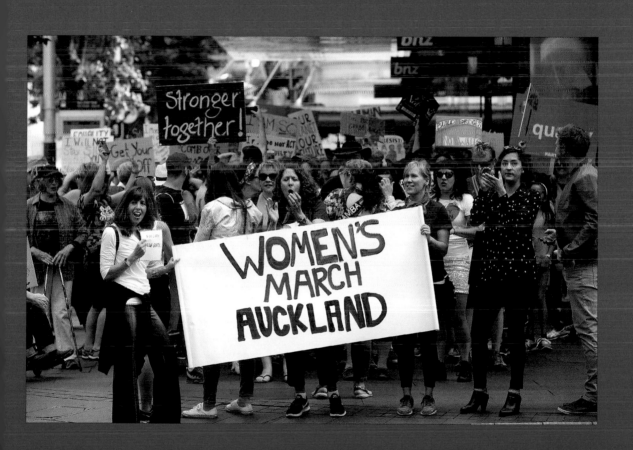

AUCKLAND, NEW ZEALAND

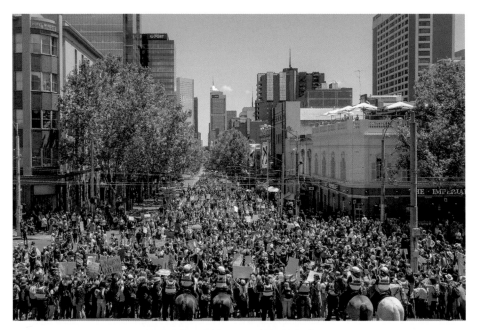

MELBOURNE, AUSTRALIA

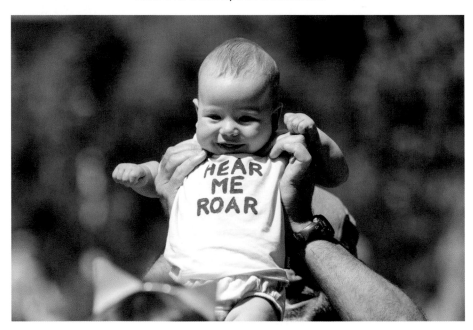

SYDNEY, AUSTRALIA

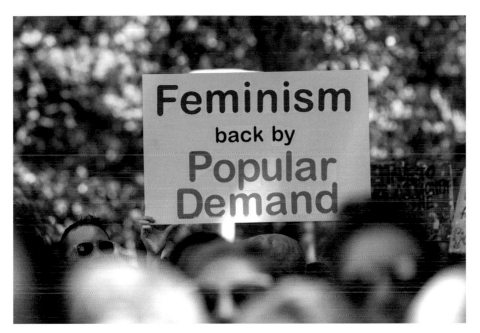

SYDNEY, AUSTRALIA

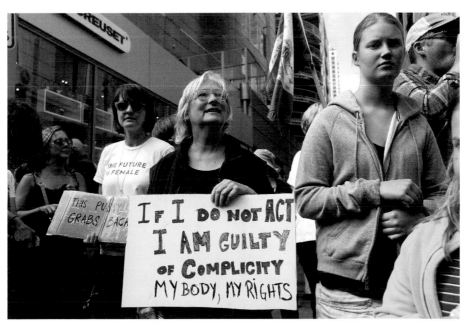

AUCKLAND, NEW ZEALAND

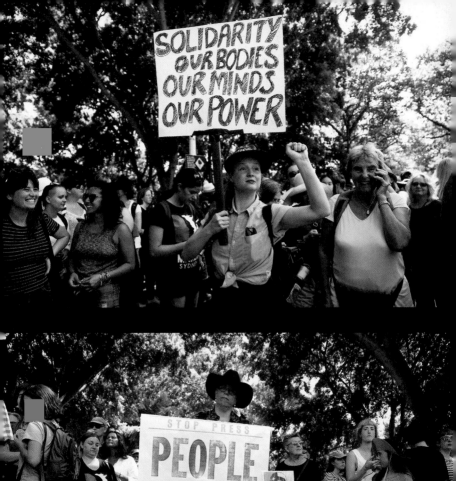

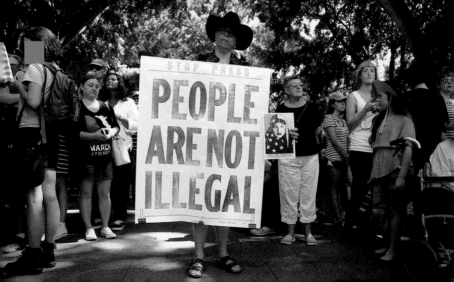

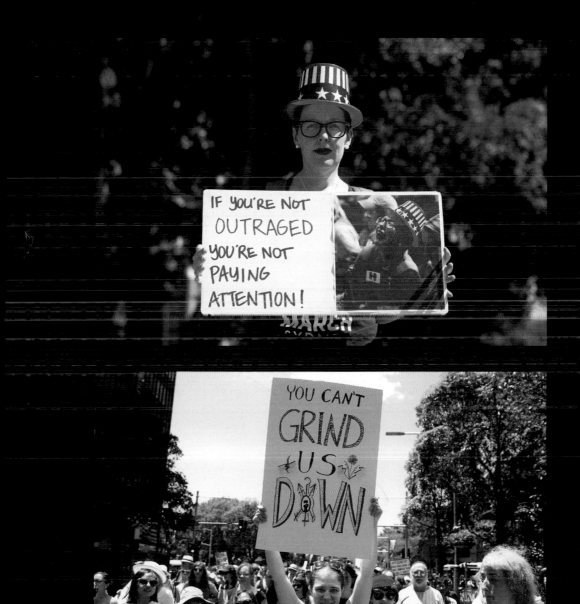

AUSTRALIA

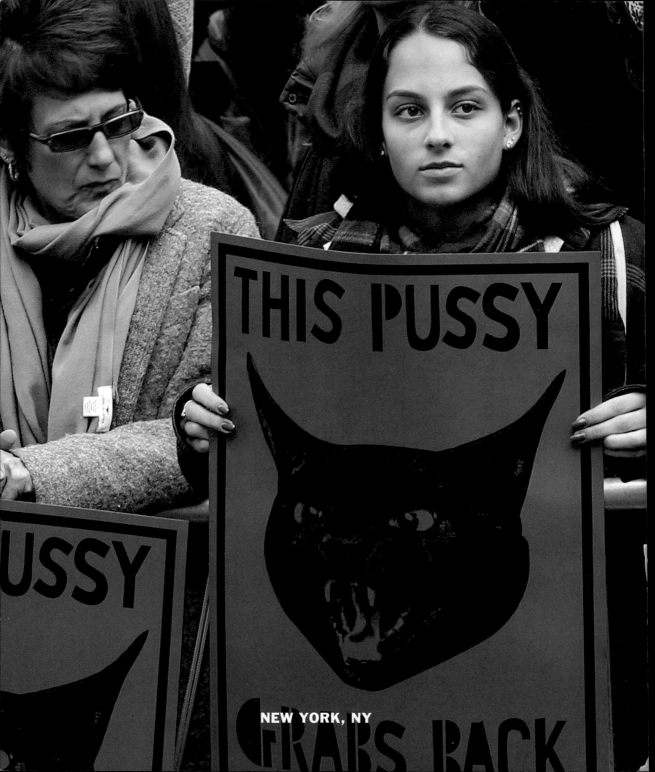

MY BODY, MY CHOICE

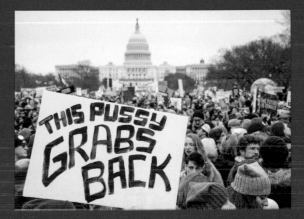

WASHINGTON, D.C.

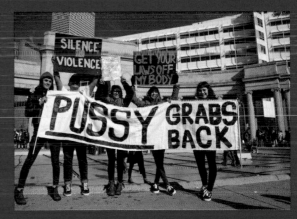

DENVER, CO

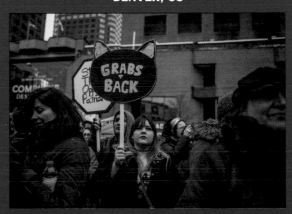

MONTRÉAL, CANADA

ANTAR

NEKO HARBOR

162

RCTICA

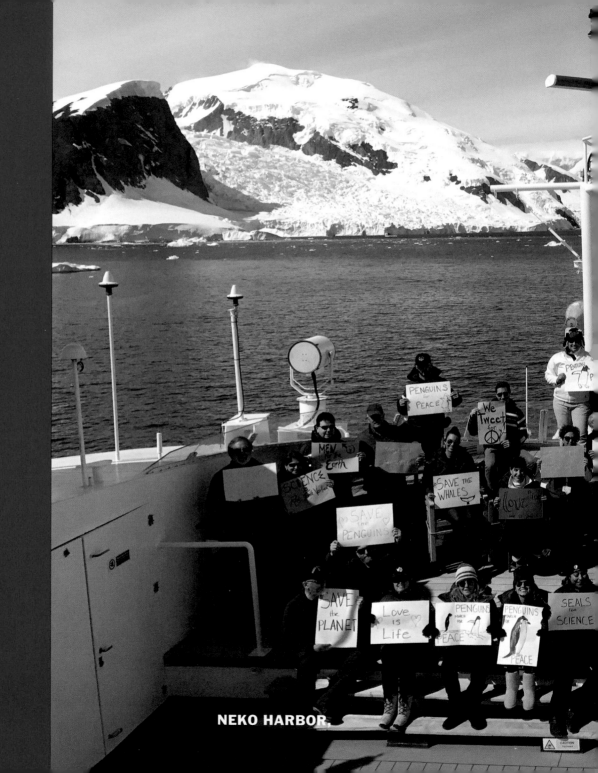

NEKO HARBOR.

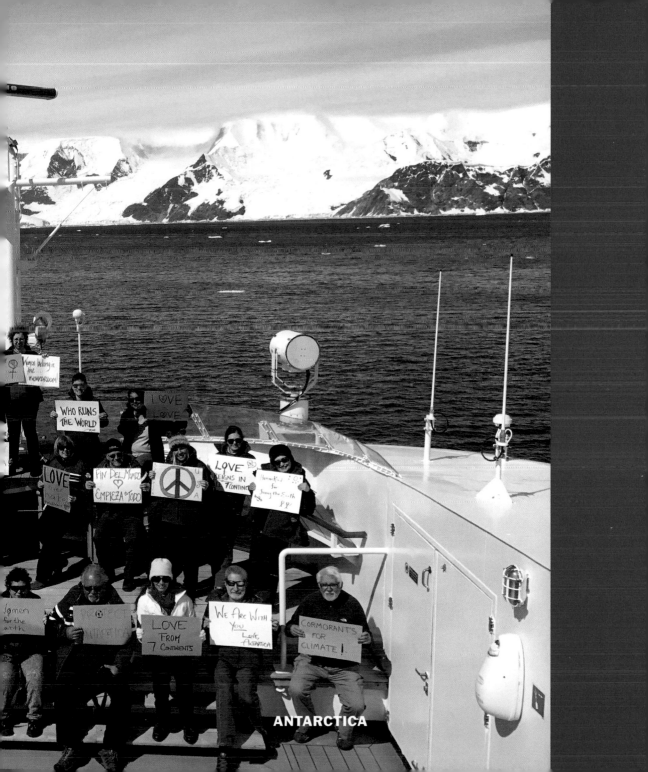

ANTARCTICA

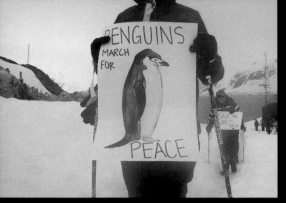

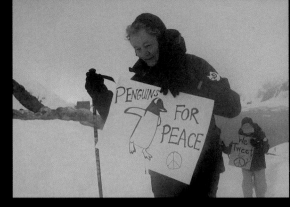

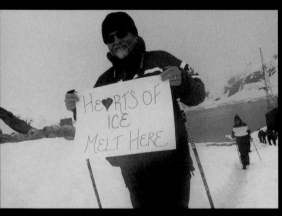

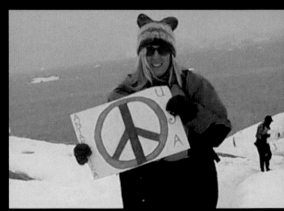

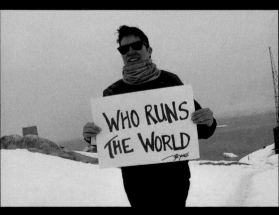

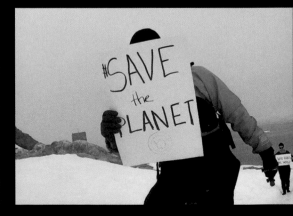

PARADISE BAY,

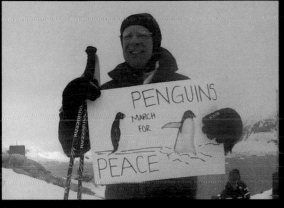

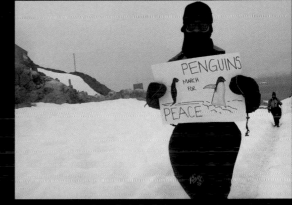

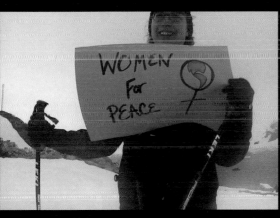

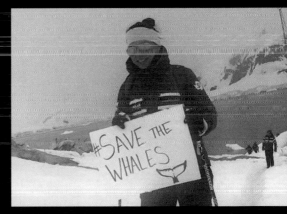

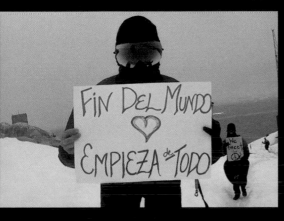

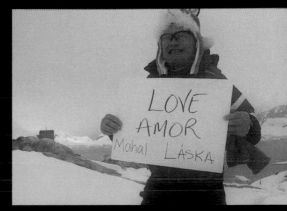

ANTARCTICA

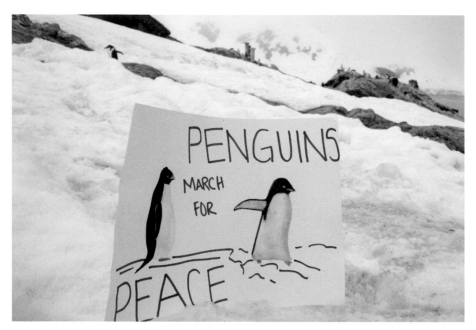

PARADISE BAY, ANTARCTICA

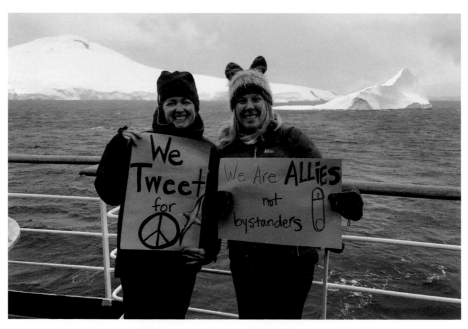

NEKO HARBOR, ANTARCTICA

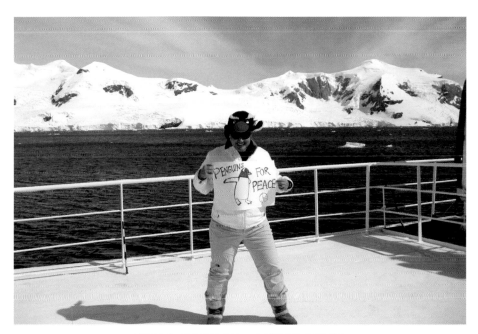

NEKO HARBOR, ANTARCTICA

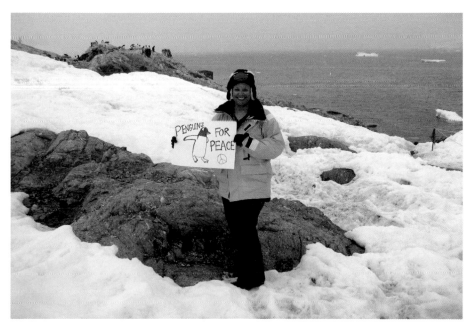

PARADISE BAY, ANTARCTICA

THE PEOPLE UNITED WILL NEVER BE DIVIDED

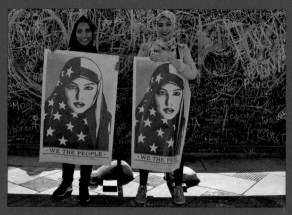

LOS ANGELES, CA

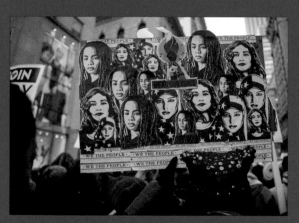

NEW YORK, NY

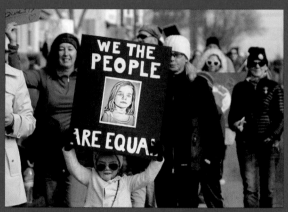

PORTLAND, ME

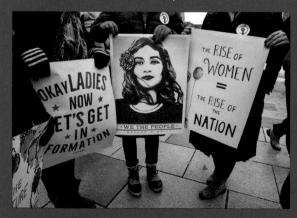

PRISTINA, KOSOVO

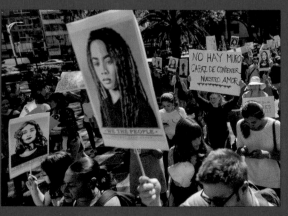

MEXICO CITY, MEXICO

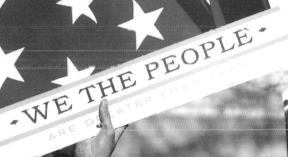

WE THE PEOPLE
ARE GREATER THAN FEAR

SocialistWorker
DUMP TRUMP
FIGHT BIGOTRY
www.swp.org.uk

No to Trump

LONDON, ENGLAND

NO JUSTICE, NO PEACE RESOURCES

**REGISTER TO VOTE AND VOLUNTEER
TO WORK AT THE POLLS:**
 http://www.eac.gov/voter_resources
 /contact_your_state.aspx
U.S. HOUSE SWITCHBOARD: (202) 225-3121
FIND YOUR ELECTED OFFICIALS:
 http://hq-salsa.wiredforchange.com/o/5950
 /getLocal.jsp
HOW TO GET IN TOUCH:
 http://www.usa.gov/elected-officials

ARTS
AMERICANS FOR THE ARTS:
 http://www.americansforthearts.org/
THE ANDREW W. MELLON FOUNDATION:
 http://mellon.org/
FRACTURED ATLAS:
 http://www.fracturedatlas.org/
**NATIONAL ASSEMBLY OF STATE ARTS AGENCIES
 (NASAA):** http://www.nasaa-arts.org/
NATIONAL GUILD FOR COMMUNITY ARTS EDUCATION:
 http://www.nationalguild.org/
**STATE AND REGIONAL ARTS ORGANIZATIONS FROM
 THE NATIONAL ENDOWMENT FOR THE ARTS:**
 http://www.arts.gov/partners/state-regional
WOMENARTS: http://www.womenarts.org/

CIVIL LIBERTIES AND LEGAL DEFENSE
AMERICAN CIVIL LIBERTIES UNION (ACLU):
 http://www.aclu.org/
CENTER FOR CONSTITUTIONAL RIGHTS (CCR):
 http://ccrjustice.org/
NATIONAL FAIR HOUSING ALLIANCE (NFHA):
 http://www.nationalfairhousing.org/
SOUTHERN POVERTY LAW CENTER (SPLC):
 http://www.splcenter.org/

CRIMINAL JUSTICE REFORM
CENTRE FOR JUSTICE AND RECONCILIATION:
 http://restorativejustice.org/
CRITICAL RESISTANCE:
 http://criticalresistance.org/
THE GATHERING FOR JUSTICE:
 http://gatheringforjustice.org

INNOCENCE PROJECT:
 http://www.innocenceproject.org/
PRISON POLICY INITIATIVE:
 http://www.prisonpolicy.org/

EDUCATION
APPLESEED: http://www.appleseednetwork.org/
**DISABILITY RIGHTS EDUCATION AND DEFENSE FUND
 (DREDF):** http://dredf.org/
**NATIONAL PARENT TEACHER ASSOCIATION
 (PTA):** http://www.pta.org/about/content.
 cfm?ItemNumber=3289
NATIONAL EDUCATION ASSOCIATION: http://nea.org

ENVIRONMENTAL ISSUES
ANTARCTIC OCEAN ALLIANCE:
 http://www.antarcticocean.org/
GREEN ACTION: http://greenaction.org/
GREEN PEACE:
 http://www.greenpeace.org/international/en/
NATURAL RESOURCES DEFENSE COUNCIL (NRDC):
 http://www.nrdc.org/
PENGUIN LIFELINES: http://penguinlifelines.org/
POWER SHIFT NETWORK ENVIRONMENTAL JUSTICE:
 http://powershift.org/campaigns/environmental-justice
SIERRA CLUB:
 http://www.sierraclub.org/environmental-justice
UNION OF CONCERNED SCIENTISTS (UCS):
 http://www.ucsusa.org/
WORLD WILDLIFE FUND (WWF):
 http://www.wwf.org

FREE PRESS AND JOURNALISTIC RESEARCH
CENTER FOR MEDIA JUSTICE (CMJ):
 http://centerformediajustice.org/
THE COMMITTEE TO PROTECT JOURNALISTS (CPJ):
 http://www.cpj.org/
NATIONAL COALITION AGAINST CENSORSHIP (NCAC):
 http://ncac.org/
PROPUBLICA: http://www.propublica.org/
REPORTERS COMMITTEE FOR FREEDOM OF PRESS:
 http://www.rcfp.org/

GENDER VIOLENCE AND SEXUAL ASSAULT ADVOCACY
HOLLABACK!: http://www.ihollaback.org/
**NATIONAL COALITION AGAINST DOMESTIC VIOLENCE
 (NCADV):** http://ncadv.org/

RAPE, ABUSE & INCEST NATIONAL NETWORK (RAINN):
http://www.rainn.org/

HEALTH AND REPRODUCTIVE RIGHTS
CENTER FOR REPRODUCTIVE RIGHTS:
http://www.reproductiverights.org/
FEMINIST MAJORITY: http://www.feminist.org/
THE ICARUS PROJECT: http://theicarusproject.net/
NATIONAL ABORTION AND REPRODUCTIVE RIGHTS ACTION LEAGUE (NARAL): http://www.naral.org/
NATIONAL LATINA INSTITUTE FOR REPRODUCTIVE HEALTH: http://latinainstitute.org
PLANNED PARENTHOOD:
http://www.plannedparenthood.org/
UNITE FOR REPRODUCTIVE AND GENDER EQUITY (URGE): http://urge.org/

IMMIGRATION
DEFINE AMERICAN: http://defineamerican.com
IMMIGRATION ADVOCATES:
http://www.immigrationadvocates.org/nonprofit/legaldirectory/
NATIONAL CENTER FOR FARMWORKER HEALTH:
http://www.ncfh.org/
NATIONAL IMMIGRATION LAW CENTER (NILC):
http://www.nilc.org/
NATIONAL IMMIGRATION PROJECT:
http://www.nationalimmigrationproject.org/
URBAN JUSTICE CENTER'S ASYLUM SEEKER ADVOCACY PROJECT (ASAP):
http://asap.urbanjustice.org/
UNITED WE DREAM: http://unitedwedream.org

LGBTQ
BLACK AND PINK: http://www.blackandpink.org/
GLAAD: http://www.glaad.org/
LAMBDA LEGAL: http://www.lambdalegal.org/
NATIONAL LGBTQ TASK FORCE:
http://www.thetaskforce.org/
SOULFORCE: http://www.soulforce.org/
SYLVIA RIVERA LAW PROJECT (SRLP):
http://srlp.org/
TRANSGENDER LAW CENTER (TLC):
http://transgenderlawcenter.org/
TRANSWOMEN OF COLOR COLLECTIVE (TWOCC):
http://www.twocc.us/

POLITICAL ENGAGEMENT
10 ACTIONS, 100 DAYS:
http://www.womensmarch.com/100
100 DAYS OF RESISTANCE:
http://www.100daysofresistance.org/
CENTER FOR COMMUNITY CHANGE:
http://www.communitychange.org/
EVERY VOICE: http://everyvoice.org/
GRASSROOTS LEADERSHIP:
http://grassrootsleadership.org/
INDIVISIBLE: http://www.indivisibleguide.com/
LEAGUE OF WOMEN VOTERS (LWV): http://lwv.org/
OUR REVOLUTION: http://ourrevolution.com/
ROCK THE VOTE: http://www.rockthevote.com
SWING LEFT: http://swingleft.org/
VOLUNTEER MATCH:
http://www.volunteermatch.org/

RACIAL AND RELIGIOUS JUSTICE
AMERICANS FOR INDIAN OPPORTUNITY: http://aio.org
AMERICANS UNITED FOR SEPARATION OF CHURCH AND STATE (AU): http://www.au.org/
ANTI-DEFAMATION LEAGUE (ADL):
http://www.adl.org/
ASIAN AMERICAN JUSTICE CENTER (AAJC):
http://advancingjustice-aajc.org/
BLACK LIVES MATTER:
http://blacklivesmatter.com/
COUNCIL ON AMERICAN-ISLAMIC RELATIONS (CAIR):
http://www.cair.com/
LEAGUE OF UNITED LATIN AMERICAN CITIZENS (LULAC): http://lulac.org/
MEXICAN AMERICAN LEGAL DEFENSE AND EDUCATIONAL FUND (MALDEF):
http://www.maldef.org/
NATIONAL ASSOCIATION FOR THE ADVANCEMENT OF COLORED PEOPLE (NAACP) LEGAL DEFENSE FUND:
http://www.naacpldf.org/
NATIONAL CONGRESS OF AMERICAN INDIANS (NCAI):
http://www.ncai.org/
NATIONAL COUNCIL ON U.S.–ARAB RELATIONS:
http://ncusar.org/
RAINBOW PUSH COALITION (RPC):
http://www.rainbowpush.org/
URBAN JUSTICE CENTER'S INTERNATIONAL REFUGEE ASSISTANCE PROGRAM (IRAP):
http://irap.urbanjustice.org/

DESIGNER'S NOTE: A TIMELINE OF EVENTS

On Saturday, January 21, 2017, a continental assembly of bodies and voices seeking a rise of action against a cumulus of oppression came together and marched.

On Friday, January 27, I was offered the opportunity to commemorate their chants through design.

I am a brown Middle Eastern Muslim woman, and a legal U.S. alien, with self-proclaimed naïve and aspirational dreams.

On Friday, January 27, exactly six days after The Women's March, an executive order on immigration was issued by the White House administration—it was a dark night.

On Saturday, January 28, a second demonstration followed, uniting Americans, immigrants, and nonimmigrants of all faiths and colors at airports across the country.

On that same Saturday, this book was drafted and assembled by three women determined to compile with urgency and immediacy a chronicle of a progressive but peaceful protest. The images represented here serve as beacons of vigilance and hope. This is the steady fire that will remind us that we are never alone when we assemble. That I march in spirit, body, and word for my voice, for her voice, for every voice.

On Friday, January 20, 2017, no one will forget that it rained.

But we will also remember that that Friday could not diminish the light of all the Saturdays to follow.

Thank you to all the women, children, and men who are taking a stand against this global tyranny whether or not it displaces their security and safety. And thank you to Samantha and Emma, for reminding me that through passion and heart, we will not despair.

—Najeebah Al-Ghadban

EDITORS' NOTE:

To every person who purchased this book, thank you for your help in supporting the incredible organizations that partnered with The March that took place in Washington, D.C., around the country and around the world. We're so grateful for these grassroots nonprofits, who fight the good fight every single day.

For more information about the organizations that this book is supporting, please go to:
www.abramsbooks.com/WhyIMarch

Thank you to Najeebah, for creating a design as beautiful and powerful as the marches were. It was an honor to make this book with you.

Thank you to every person who stood up and marched on January 21, 2017. You inspired this book. We were proud to march with you. We must keep marching forward together.

—Samantha Weiner & Emma Jacobs

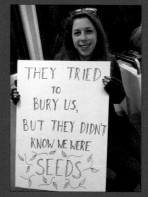
Samantha Weiner

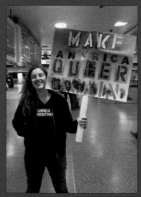
Emma Jacobs

Najeebah Al-Ghadban
A personal collage translating "noor" in Arabic to "light"

GETTY IMAGE CREDITS

Editors: Samantha Weiner and Emma Jacobs
Designer: Najeebah Al-Ghadban
Production Manager: Anet Sirna-Bruder

ISBN: 978-1-4197-2885-3

ABRAMS
The Art of Books

115 West 18th Street
New York, NY 10011
abramsbooks.com